Santiago Arcas
José Fernando Arcas
Isabel González

MASTERING
PERSPECTIVE

for Beginners

KÖNEMANN

PERSPECTIVE
All Rights Reserved
Copyright © Atrium Group 2003
Text Copyright © Atrium Group 2003
Artwork and Commissioned Photography Copyright © Atrium Group 2003

Authors: Santiago Arcas, José Fernando Arcas and Isabel González
Graphic design: David Maynar
Project management: Arco Editorial S.A.

Original title: *Perspectiva para principiantes*
ISBN 3-8331-1739-7

© 2005 for the English edition: Tandem Verlag GmbH
KÖNEMANN is a trademark and an imprint of Tandem Verlag GmbH

Translation from Spanish: Gillian Wallis in association with
Cambridge Publishing Management
Editing: Kay Hyman in association with
Cambridge Publishing Management
Typesetting: Cambridge Publishing Management
Project Managment: Sheila Hardie for
Cambridge Publishing Management
Project Coordinator: Kristin Zeier

Printed in Slovenia

ISBN 3-8331-1737-0

10 9 8 7 6 5 4 3 2 1
X IX VIII VII VI V IV III II I

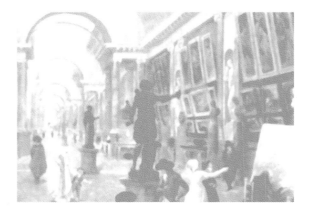

Perspective: techniques42

Step by step exercises144

I. Introduction

In Japanese art, space is not represented by a type of perspective that imitates the way in which we see the reality surrounding us, but a system has developed that expresses space clearly and with a great sense of narrative.

In the attempt to capture reality on paper or canvas, artists often encounter a common problem: the representation of depth. Between the world that surrounds us, that of real objects that are around us, and that of the same objects in a picture, there is an important difference: while in the former there are three dimensions, i.e. height, width, and depth, in the latter there is only height and width. Thus we are dealing with a two-dimensional, not a three-dimensional, reality. Therefore, what artists do, when representing a particular scene that they see around them, is to make an authentic translation from an already existing reality to another totally different one that they create with the use of certain rules. These rules are what we are going to study in this book, which aims to be a useful guide for artists who wish to develop or improve their skills in the field of drawing and painting in perspective.

We must understand that, although a particular scene in perspective seems very real and obvious to us, in reality it is one more feature of our cultural inheritance. There is no absolute norm for depicting the reality that surrounds us in a totally reliable manner, but rather there are different ways of approaching what might be a satisfactory representation.

We must also remember that perspective has only been part of the pictorial tradition since

the Renaissance, and then only in Western culture. In other cultures and in earlier times, people had other ways of expressing the three dimensions on a flat surface.

Whether or not perspective is used does not, of itself, make a piece of art work better or worse. In fact, the art of the 20th century has given greater importance to this subject than have previous centuries.

However, there is no doubt that perspective is a powerful instrument at the disposal of the artist whose work reproduces a scene in a way that is very close to how we see it in reality. It is therefore advisable to have some knowledge of the subject in order to be able to express ourselves with confidence in the field of realistic drawing and painting.

A brief history

The problem of representing depth on a flat surface has been solved in very different ways over the course of history. As we will see in this brief study of the various ways of approaching this subject, these solutions have been determined not only by the greater or lesser degree of technical skill available at any particular moment, but also to a great extent by the way of thinking and cultural characteristics of each age.

The classical world

The concept of perspective has not always existed, and it has not always been applied as it is now. This is because artists have not always needed to represent the three dimensions, much less to do so by trying to imitate the image-capturing mechanism of the human eye. In ancient Greece ideas were already being developed which, to a certain extent, were quite similar to

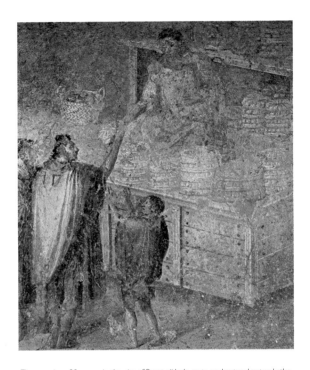

The remains of frescoes in the city of Pompeii help us to understand not only the way of life at the time, but also the manner in which the artists of ancient Rome created a sense of depth in their works.

In this painting, which represents a bakery, the different elements are arranged in a way that suggests three dimensions. Although perspective had not been mathematically systematized, it was being used intuitively and produced convincing results.

those that would give rise to the systems of perspective much later. Euclid developed a complete theory of how we see the things that surround us. This theory is based on the idea that a series of rays emerges from the eye as an invisible cone, directed towards the object that we see. As we know today, the eye does not in fact emit such rays, but receives the light that objects reflect, the origin of such rays being the sun or any other source of light. However, Euclid's theory, although it confuses the transmitter with the receiver, is correct in arranging

the beams of light as a cone. This explains how we have a limited angle of vision, why parallel lines come together in the distance, and why objects are reduced in size when they are further away. Although Greek painting was not concerned with the subject of perspective, Roman painting, its immediate successor, featured many instances of architectural spaces represented with a vanishing point and a close approximation to perspective.

The Middle Ages

Since during the Roman era a type of representation quite close to that of perspective had been achieved, it may seem strange to us that in the Middle Ages techniques were used which completely ignored the laws of optics and rules regarding three-dimensional forms discovered in the preceding period.

This reversal was due to the change in the cultural climate. The naturalist representation of reality and the search for physical beauty and perfection ceased to be of interest. Space was converted into something symbolic and idealized, and the artist tried to convey his message through the composition as directly as possible. The naturalist principle of a single viewpoint was abandoned, so that in a single scene, even in a single figure, each part was drawn from the viewpoint from which it could be seen with the greatest clarity.

From the end of the Middle Ages to the beginning of the Renaissance, that is, from the 13th century onwards, a certain form of perspective was reinvented. At this time nothing was systematized yet, but some elements were already moving away substantially from medieval images and forms of representation.

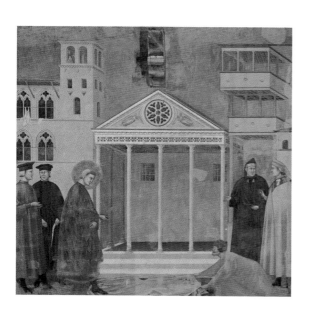

Giotto, Franciscan cycle (1300). Giotto's painting constitutes a real change from the Gothic art prevailing in that era. The figures have mass and are superimposed one on top of another in a natural way. Although the architectural space still does not have a defined vanishing point, it is closer to realism than that of medieval art.

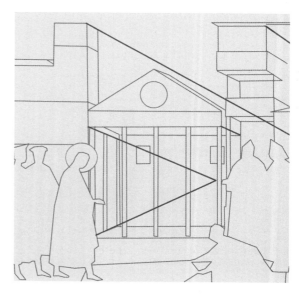

As one can see in this drawing, all the architectural elements are aligned more or less in one direction, although the vanishing points have been realized intuitively and have no clear meeting point.

The Renaissance

It is usually said that medieval painting ended and Renaissance painting began with the birth of Giotto in about 1266.

Prior to this figures had never had mass or been superimposed in the way they would actually be seen in reality. Moreover, attempts at foreshortening began to emerge and the design of the scene where the people are situated was also enriched by the application of many of the principles that would soon underpin perspective.

The intuitive search for spatial unity and different ways of representing depth began to develop along with the central principle of perspective, which was formulated for the first time in Italy by artists and architects such as Alberti, Brunelleschi, and Piero della Francesca. These tried to achieve objective representation, a technique that was independent of the sight and the hand of the artist.

The work of the Florentine architect Brunelleschi (1377–1446) showed that he was already aware of the importance of the viewpoint and that within the picture this coincided with the point at which the parallel lines vanish.

This viewpoint is situated on the line of the horizon. Moreover, something very important was now realized: perspective presupposes that the person observing actually does this from a

Piero della Francesca, The Flagellation of Christ. (c. 1450). In this work the perspective succeeds in becoming the focus of the work, almost over and above the depicted theme. Although the technical principles of central perspective are now firmly established, the picture as a whole has the air of a stage set rather than a real scene. The construction is almost mathematical: the arrangement is front facing and the figures are distributed in rectangles in proportion to the architecture.

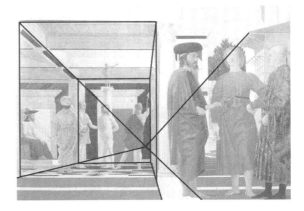

In this work there is a clear vanishing point situated in the center of the lower part of the composition, so that the figures in the foreground appear to be seen from a rather low viewpoint and acquire greater authority. The picture can be divided into an interior space, in which the flagellation scene is situated, and an exterior space.

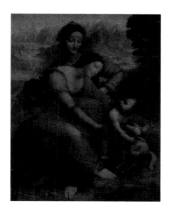

Leonardo da Vinci, Virgin and Child with St. Anne *(1510)*. *Two of this artist's most important contributions to painting are atmospheric perspective and sfumato. As one can see, the countryside in the background is much paler, with less saturated colors than in the foreground. In addition, the outline of the figures seems blurred, giving a sense of mistiness.*

specific viewpoint, that is, a single unmoving eye (taking into account the fact that human vision operates through the eyes).

Alberti (1404–1472) contributed significantly to the theoretical basis for mechanically correct reproduction. His idea of a visual pyramid was a direct descendant of what had been formulated by Euclid many years earlier, only improved upon.

It was founded on the idea that the optical relationship between the eye of the observer and the observed object can be represented by a system of straight lines which, starting from each point on the front surface of the object, come to a stop at the eye. The result is a pyramid of light rays which, when cut through perpendicular to the line of sight by a glass sheet, form an image on the sheet which is a projection of the object. Thus, if the outlines of the object were marked on the sheet just as they are seen from the observation point, it would be possible to register an exact duplicate of the image.

In his writings on perspective, Leonardo da Vinci (1452–1519) relied on Alberti's concept of the transparent veil or sheet of glass on whose surface are drawn the objects that lie behind it. Furthermore, this same concept laid the foundations for the principle of the camera obscura which, centuries later, was to culminate in the invention of the photographic camera. Nonetheless, Leonardo maintained that, in the first place, artists should trust their own sensibilities and exercise their powers of sight, and not be guided too much by theories.

But, without doubt, Leonardo's greatest contribution to perspective was his studies of the behavior of color according to the distance or proximity of the spectator. Leonardo began to realize that the air surrounding objects is not totally transparent, and that when the amount of air between the objects and the spectator is very extensive (that is, when they are quite far away), their color becomes more blue and the outlines are blurred.

The painter Raphael Sanzio (1483–1520) can be said to have combined the teachings of Leonardo with those of Michelangelo to create works of art with great compositional feeling and correct use of perspective, producing a synthesis which best represents the High Renaissance.

Later developments

Subsequent artists and researchers with a continued interest in this subject have made their own contributions.

One of these was the German painter Albrecht Dürer (1471–1528). Some of his wood block prints show the mechanism used for representing scenes in perspective. The artist looks through a peephole to ensure that the viewpoint does not vary throughout the whole process. In this position, he traces the outlines of the model onto a transparent vertical sheet. Then, by means of a grid, the acquired drawing is transferred to the support of the final work of art.

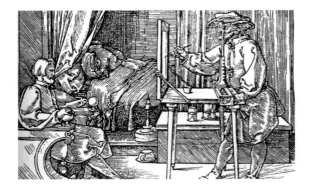

Albrecht Dürer, illustration from the treatise Underweyssung der Messung (Teaching Measurement) *(1525). This shows the use of the drawing frame.*

As it was gradually assimilated and generalized over the course of the centuries, the application of perspective became one more resource which artists automatically used and which was consid-

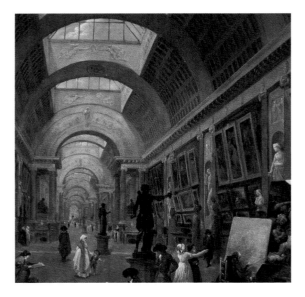

Hubert Robert, View of the Great Gallery of the Louvre *(1796). Over the centuries the dominance of perspective was transformed into something more generalized.*

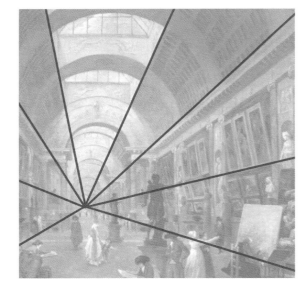

Within the art world some established academic centers were so powerful that this form of representation was considered to be the only correct one.

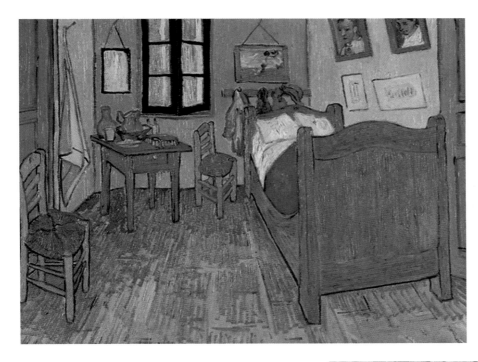

Vincent van Gogh, Bedroom at Arles *(1889). Although perspective is still used in this work, it appears to be exaggerated in order to emphasize the feeling that the painter wishes to transmit. The artist is no longer attempting naturalistic representation but instead he uses reality as the basis for distributing a series of vigorously expressive brushstrokes. Although it may seem that the perspective in this and the previous works is not very different, in fact there exists here an interest other than that of representing reality as we see it.*

ered the logical form of representation. This situation, with the generally accepted employment of perspective, was maintained almost up to the end of the 19th century, when the post-impressionists began to manipulate the depiction of space, being greatly influenced by oriental art, which at that time began to gain a great deal of interest in Europe. Gauguin was painting pictures in which the space appeared to be flattened by the use of color. Van Gogh was emphasizing the effects of distorting space in his compositions, and Cézanne dedicated himself to making natural forms geometric. All of these artists continued to maintain the basis of perspective, but their works gave way to the artistic vanguard of the 20th century, which often dispensed with it altogether.

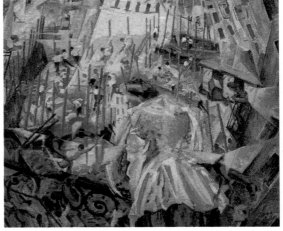

Umberto Boccioni, The Sounds of the Street Fill the House *(1911). In the 20th century the representation of space was finally liberated from the use of perspective. Artists began to dictate the rules of how space would be represented in their work. In this picture by the Italian painter Boccioni, the artist has completely altered the perspectival positioning of the buildings so as to suggest the movement and speed of the modern city.*

Perspective: ge

eral concepts

 # 1. Arrangement and structure of objects

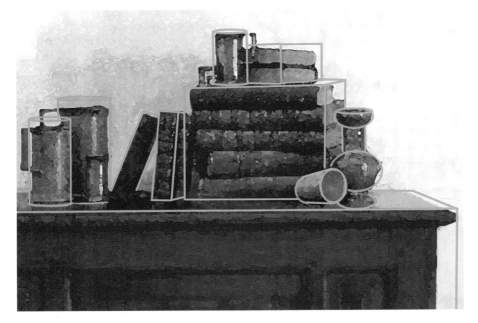

 Fig. 1

In this composition one can see how the piece of furniture, the books, and the containers are represented using cylinders, cubes, and parallelepipeds, even though there are objects, such as the jar on the right, that may need a more complex type of treatment. The glass has been interpreted as a truncated cone.

Often, when faced with the challenge of drawing a composition, this can seem very complex, with its very intricate forms, so much so that we may feel discouraged and incapable of tackling it successfully. Certainly, both natural and artificial elements present a huge variety of different forms, often not arranged in an ordered manner, so that the inexperienced artist might feel overwhelmed and not even know where to begin.

It is important to bear in mind, therefore, that, when depicting an object or a scene, the process must begin with something which is as important as, or more important than, the actual drawing: that is, observing. Knowing how to

draw or knowing how to paint is directly related to, and depends to a great extent on, knowing how to observe, which is not simply looking at things. The artist must first organize the actual scene in order to then transfer it onto paper or canvas (the same applies to sculpture) and, in this ordering process, the first thing you need to know is how to capture the essential elements.

As we can see, usually, when we depict examples of objects in perspective, we do so with geometric shapes such as cubes, cylinders, or prisms. This is because it is precisely these geometric forms that will later be useful to us when we come to tackle more concrete forms

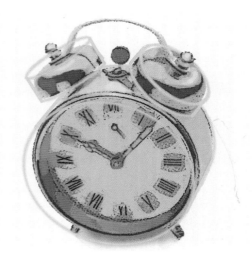

 Fig.2

This alarm clock, owing to its greater complexity of form, has been interpreted by means of three cylinders positioned obliquely. Sufficient information about the object is obtained through these three elements.

which appear in real life, such as buildings, cars, furniture, or even people.

One of the concepts that artists use when drawing is that of compositional arrangement. The inexperienced sketcher is often carried away by the details attracting their attention and loses the overall picture of what they are doing. This results in a lack of planned proportion and coherence. In order to avoid this it is first necessary to understand general shapes and to combine them correctly, tracing the principal lines that define the composition. When the basic geometrical forms that make up the arrangement have been correctly placed in perspective, there is a greater likelihood of being able to outline the object

piece by piece and gradually to approach the desired result.

It is helpful to practice reducing different objects in an arrangement to simple geometrical forms in order to learn how to observe reality in a more abstract way and to have greater control of drawing in perspective. As we can see, there are simple objects, such as the books in *fig. 1*, which can be reduced to single geometrical forms, in this case parallelepipeds. There are other objects, however, such as the alarm clock in *fig. 2*, which, owing to their greater complexity, require a combination of various geometrical forms (in this case, three cylinders). Of course, a complex object can also be represented by a single geometrical form. For example, the alarm clock could be interpreted as a single parallelepiped completely encompassing it, but this option would not be so helpful in drawing the clock correctly in perspective.

The degree of abstraction that is applied to each object depends on the shape or the importance that this object has within the entire picture. If it is only a small part of the greater composition, it can be interpreted in a simpler form. In fact, it is sometimes better not to create an initial arrangement that is too complicated. Doing so could mean that the overall effect of the picture is lost, and the arrangement of the objects is rendered completely useless.

perspective: general concepts

 # Step by step

A few books can provide a good first subject for a work using perspective. The positioning of the components is very important, as the composition of the picture will be based on this. Books are very suitable elements for geometrical abstraction due to the regularity of their form.

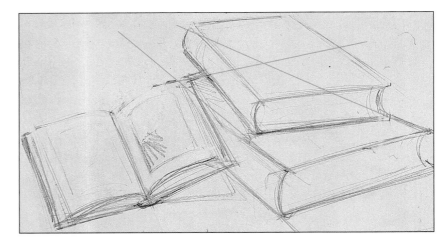

 1

The drawing is first done in pencil. Pay attention to how the lines vanish.

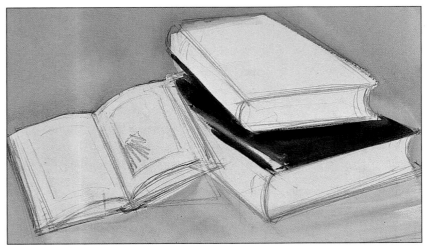

 2

The first color wash applied is a transparent sienna color, with which the whole background is filled in a uniform way. The tone used must not be too dark.

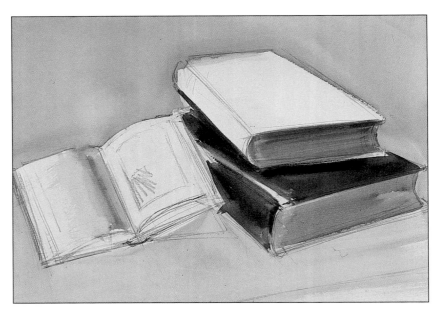

The spine of the book, as well as the shading of the pages, is painted in a dark brown tone.

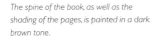

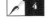

The shadow that is produced by the open book, which places the book within the space, is painted with a light pure blue color wash.

Step by step

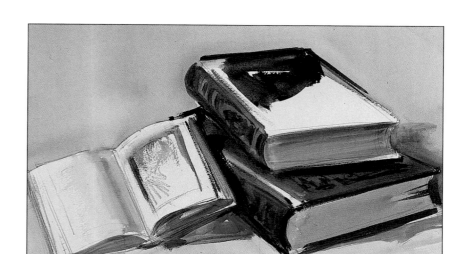

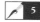

Although both books are of a similar color, it is important to give them a different shade in order to differentiate them.

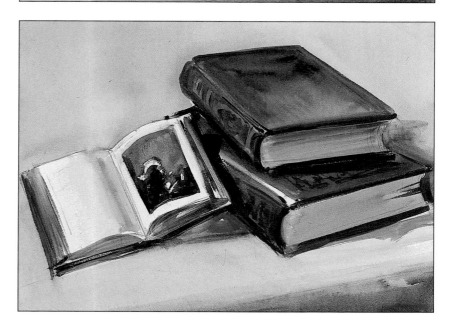

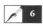

As can be seen, the tone of the shading becomes more diluted at the back.

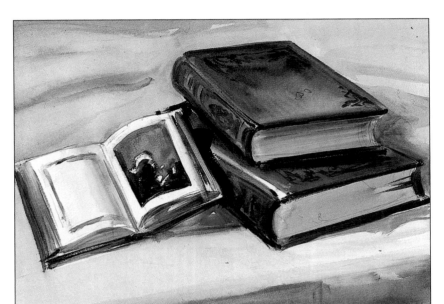

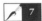 **7**

The dark area in the lower right-hand corner helps to suggest the shape of the table.

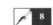 **8**

Now finish painting the left-hand page of the open book. This completes this task of assembling shapes.

2. Basic concepts and terminology

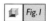 Fig. I

Although we know that railroad tracks are parallel, when we look at them they seem to meet on the horizon. This is one of the main effects of perspective.

Perspective enables the creation of an illusion of reality on a two-dimensional surface. What we use on paper (and what we study in this book) is called linear perspective, which is based on natural perspective.

On observing the reality that surrounds us, we note clearly that objects appear smaller the further they are away from us. We also see that two parallel lines converge in the distance until they unite on the horizon line, as in the case of railroad tracks. The main reason is that the angle that the eye must cover, in order to take in a whole object, becomes smaller as the latter fades into the distance.

In the same way, the angle that the eye covers when looking at railroad tracks becomes smaller

and smaller as these tracks fade into the distance. The technique of perspective has some rules for calculating such effects.

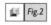 Fig.2

The red square appears smaller than the orange one because, given its situation, the visual angle required to cover it is smaller. This is the reason why objects seem to diminish in size in the distance.

Cone of vision

This corresponds to the visual field covered by sight, without the observer needing to move. It is a cone whose vertex is in the eye and which is directed ahead, encompassing the object or scene being observed. This cone is formed by rays of light that travel from the object to the eye, transmitting the image.

Ground plane (GP)

This is the level where the observer and the object are placed.

Picture plane (PP)

This is an imaginary vertical plane on which the drawing is done. It is the equivalent of the canvas or paper that we are going to use. Imagine it as the glass of a window which is positioned perpendicular to the line of sight and through which we view the scene.

Ground line (GL)

This is the line marking the intersection of the ground plane and the picture plane. In practice it is used for measurement.

Horizon line (HL)

This is an imaginary horizontal line situated at the height of the observer's eye. It corresponds to eye level, at the point at which it intersects the picture plane. The height of the horizon line varies depending on whether the viewpoint goes up or down; for example, if we draw perspective from the top of a mountain, the horizon line will be situated very high in the picture.

Line of sight

This is the line from the eye to the picture plane and is perpendicular to the latter.

Vanishing point (VP)

According to the type of perspective, there may be one, two, or three vanishing points. These are the converging points of the parallel line that move away from us and appear on the

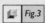 **Fig.3**

In this diagram we can see how the different elements we have mentioned are positioned in space. From the spectator's viewpoint (V) a line emerges which falls perpendicularly upon the picture plane, at a point that we will call the center of vision (CV). The two vanishing points form an angle of 90° with the viewpoint of vision at eye level on the picture plane. The two 30° angles show the extent to which we can see a totally clear image, beyond which angle it becomes blurred.

horizon line, provided that these parallels are also parallel on the ground plane (that they are not tilted). The fact that the horizontals converge on them is what creates depth.

Viewpoint (V)

This is the place where the observer's eye is situated. As we will see, perspective follows the supposition that the spectator views the scene with a single eye, in such a way that the viewpoint is a single point.

3. Parallel perspective

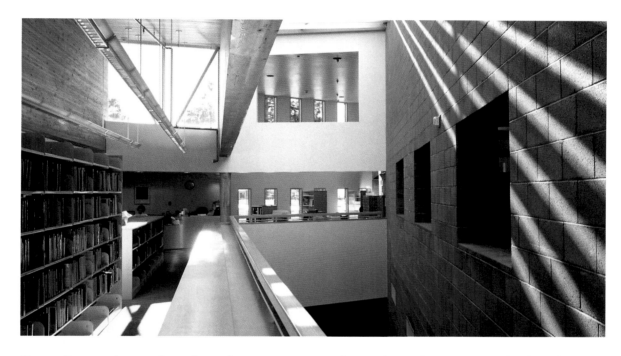

Depending on the number of vanishing points that are used to draw in perspective, three very different types of representation of space in depth can be obtained.

The first type of perspective that we are dealing with here is parallel perspective. This involves the same concept of central perspective that we referred to in the historical section, when covering the advances in perspective of the Renaissance.

Parallel perspective is used when what is to be represented is one or several objects whose front side is parallel to the picture plane and whose other sides are perpendicular. This type of perspective is characterized by having one vanishing point. This point is situated where the horizon line and the central line of sight cross. The central line of sight is the one ray, out of all the rays extending from the spectator's eye to the object, that is totally perpendicular to the picture plane. Thus, in the picture, the vanishing point and the viewpoint coincide.

At this vanishing point all the lines that remain perpendicular to the picture plane converge, so it is the center of reference for the majority of the lines that are drawn when representing this type of perspective.

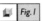

Fig. 1

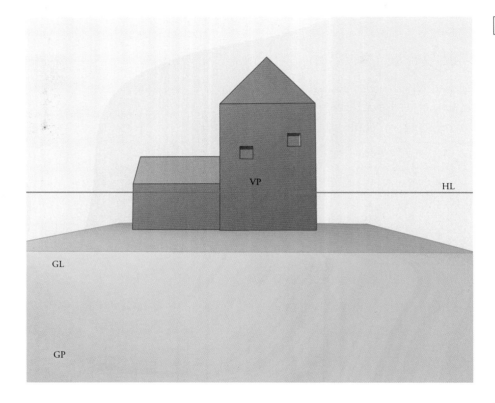

From this diagram we can gain an idea of what the spectator sees from the viewpoint. Due to the position of the object, in parallel perspective one of its sides can be seen totally front on. The horizon line (HL) marks the height at which the spectator is situated. There is only one vanishing point (VP) situated on this line. All the lines that are perpendicular to the picture plane (PP) vanish to this point.

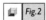

Fig. 2

The arrangement of elements in parallel perspective can be seen in this diagram. From each point of the object that is being observed a ray emerges directed towards to the spectator's eye (V). Between the observer and the object a vertical plane (PP) is located, which the rays transect. As can be seen, the front side of the object is parallel to this plane.

perspective: general concepts

Step by step

The parallel or vanishing point perspective is very prominent with a subject such as this, where there are several elements of the same size aligned in depth.

The progressively diminishing size of the trees creates the effect of perspective in a very simple way.

First, the arrangement is planned in charcoal. In this initial preparatory sketch only the principal shapes are established.

Color begins to be applied both on the trees and in the background. The color of the sky is light and is not very saturated, in order to suggest distance.

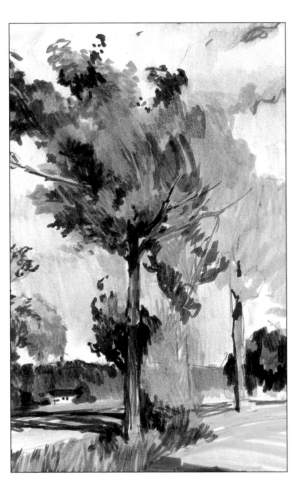

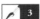

Darker color is applied to the trees situated in the foreground in order to obtain the effect of depth. Detail is given to the grass at the bottom. The shadows cast by the trees onto the road help to place them. The shadow on the ground marks the land boundary.

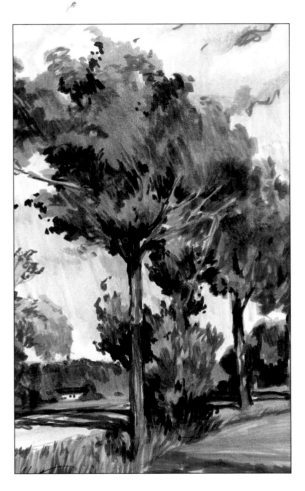

We can see that the vanishing point in this perspective is located on the right outside the picture.

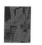

Step by step

House in the country

In this case we are going to tackle an example of parallel perspective based on a house in the country. You can see that the front wall of this house is parallel to the horizon line.

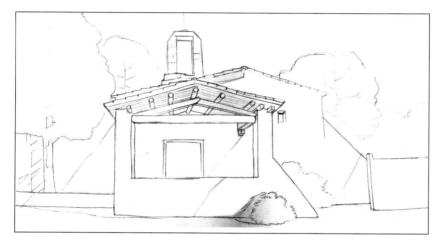

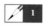

First the drawing is sketched in pencil. As is shown, the arrangement of the house's roof beams presents a clear parallel perspective. All of the beams vanish towards a point situated on the horizon line. Once the beams are drawn in the correct perspective, the lines that extend towards the vanishing point are no longer needed. It is therefore better to rub these out before beginning to paint.

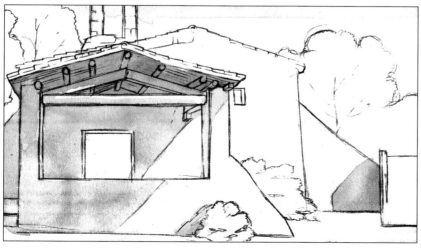

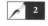

The whole area of the house under the roof has marked shadows. We paint them in a brown tone to create a contrasting effect.

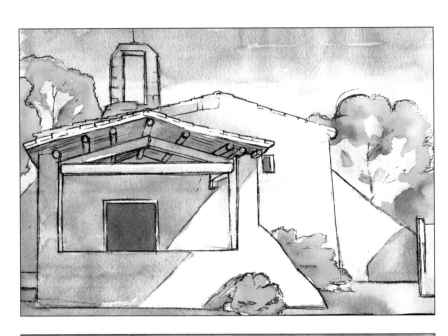

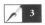

Continue with the vegetation, applying green tones to the trees in the background and the grass in the foreground. The blue tone of the sky is not too intense.

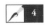

The shadow contrasts are emphasized with a dark violet tone. The shadows on the front wall make it clear that the roof projects forwards.

4. Oblique perspective

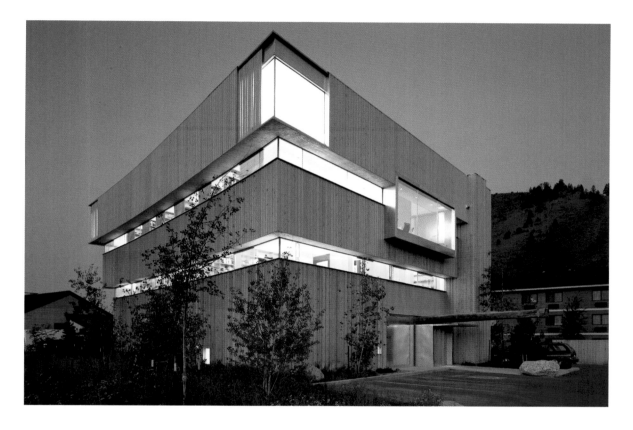

In practice, on most occasions when we wish to draw a scene in perspective the objects around us are not set out in parallels and perpendiculars with their front-facing sides totally parallel to the picture plane. In the majority of cases, the elements of the scene are situated forming a fixed angle with respect to the picture plane, so parallel perspective cannot be used when depicting them. In these instances oblique perspective must be used instead.

In oblique perspective, objects are situated obliquely in relation to the picture plane, which is why, from the observer's viewpoint, not one of its sides can be seen fully front on. Rather, two of the sides form a fixed angle with respect to the picture plane. Consequently, there are groups of lines that are parallel at the object and we can see how, from the observer's viewpoint, each one extends to a vanishing point. Explaining it in another way, lines that are parallel on the figure all vanish to the same point. If a building is

drawn with two sides visible (that is, one of the corners looks at us face on), all the horizontal lines of each side of the building will unite at a determined point, hence having two vanishing points. In addition, it is important to know that both vanishing points are situated at the exact same height, directly on the horizon line, one on the right and the other on the left.

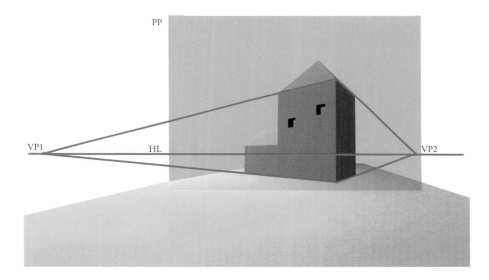

 Fig. 1

From the observer's viewpoint the object vanishes to two different points. In the diagram we can see that the lines from the base of one side of the object vanish towards point VP1 and those of the other side towards point VP2. All the lines parallel to these must vanish towards those same points. As shown, both points are at the height of the horizon line.

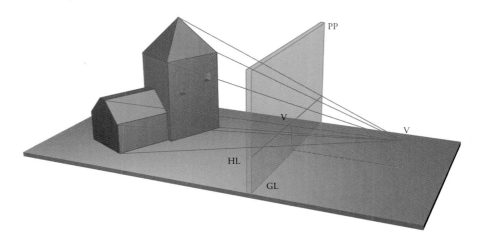

 Fig. 2

In oblique perspective the object is no longer situated parallel to the picture plane, but forms a fixed angle with it. Hence, the part of the object nearest to the observer is not a plane, but an edge, that is, the intersection of two planes.

◼ Step by step

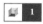

Washbasin

To illustrate an example of oblique perspective we have chosen this washbasin, in which the typical characteristics of this kind of perspective can be seen. Because of the viewpoint of the artist, none of the sides of the washbasin can be seen horizontally, but there are two vanishing points.

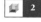 1

In this exercise it is particularly important that the sketch is perfectly drawn. The subject of the picture demands great delicacy of line and in the depiction of each of the planes.

2

Owing to the complexity of the sketch, it is advisable to study the principal lines on the paper in order to sketch the washbasin freehand in the correct perspective. The fact that the washbasin has a rectangular shape helps with the perspective.

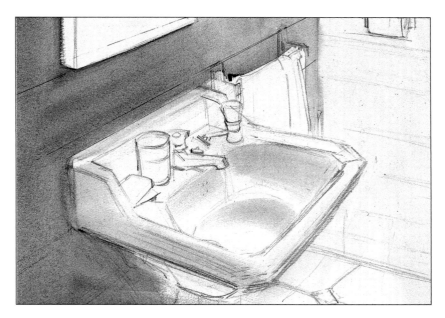

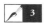

The first area to be painted is the tiled wall on the left; this wall establishes the first of the many tones that appear in the picture. The color is a very transparent blue. The interior of the washbasin is painted in a much more luminous version of this color and most reflective areas are left in white. Inside the washbasin the blue color lightens before reaching the white parts, so as not to cut off abruptly. The side of the basin is painted in the same luminous tone.

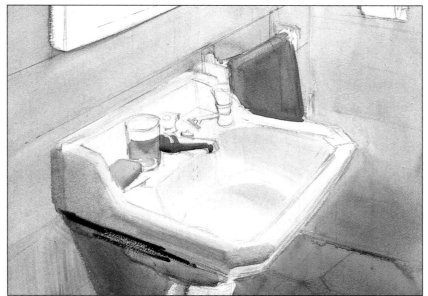

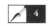

The facing wall is painted, beginning with a lighter tone than the previous wall, but on its lower part we will use a deeper shade, closer to a blue, which, as a dark tone, will contrast with the white areas. The towel is painted green, so the upper edge of the washbasin stands out; this way, the lustrous white of the washbasin will fit perfectly among the darker tones.

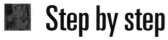

Step by step

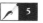

Begin the modeling of the white colors in the interior of the washbasin. It is important that the whole of this area is treated with special care, as the changing light reflections are particularly subtle. The most luminous planes lack hard tops or corners, and all the edges of this ceramic object are softened, with no straight edges; this means we have to paint while blending lightly and smoothly.

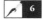

When painting the floor, it is important that the line separating it from the wall on the right is almost parallel to one rim of the washbasin, whereas the tiled walls must be parallel to the other side of the washbasin. At this stage new contrasts to the darker whites will appear. A violet wash is used to paint the darker flat areas of the washbasin; and some brushstrokes are applied to the tiles to represent the refraction of light. The washbasin's shadow on the wall is painted in dark gray and the dark color on the front rim of the washbasin is drawn in.

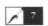

The differentiation of the various planes comprising the washbasin is almost finished. The washbasin's shadow on the wall is softened and the elongated shadow of the mirror is painted with a touch of very light blue color. Draw the lines of the tiles on the wall, on which some shine is produced with the paintbrush. Then contrasts are painted on the washbasin and details of the accompanying elements begin to take shape.

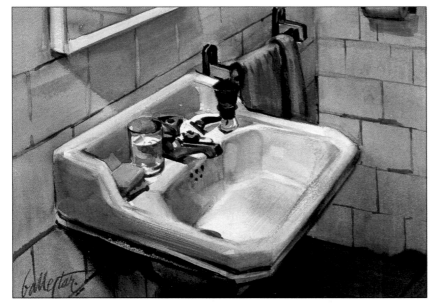

Paint the dark areas under the washbasin, and also the line framing the tiles on the wall in this area. Some very light contrasts with blue are made on the inside of the washbasin and certain excessively lustrous parts of the rim of the washbasin are tinged with an almost transparent sienna glaze. Finally, on the towel, a light yellow glaze is applied to the light area.

5. Aerial perspective

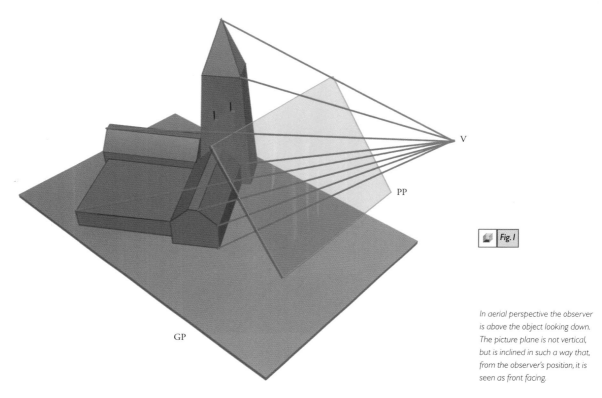

V

PP

Fig. I

GP

In aerial perspective the observer is above the object looking down. The picture plane is not vertical, but is inclined in such a way that, from the observer's position, it is seen as front facing.

In both parallel and oblique perspectives, we start from the supposition that, whether it is a side of the object or an edge, they are completely parallel to the picture plane, i.e. the vertical lines are front facing and are therefore parallel. Nevertheless, there is a third type of perspective in which, due to the position of the spectator, those vertical lines are not parallel, but vanish towards a third point.

The best way to explain this is with an example. Supposing you are on top of a skyscraper and from there, looking down, a series of smaller buildings can be seen. The vertical lines of the buildings, on being surveyed from above, do not look parallel although actually they are, since, due to the effect of perspective, they converge at an imaginary point. For this reason, the facades of the buildings, when seen from above, become smaller further away.

In fact, in these cases, what happens is that the picture plane, in which the in-depth image is represented, ceases to be vertical. Since this plane must always be perpendicular to the line of sight (which, as we know, is the central line of that

imaginary cone formed by the rays of light that reach our eye from the object), if we look down, this line of sight is no longer horizontal, so the picture plane also tilts away from the vertical.

Therefore, this type of perspective adds to what we know about the elements of the two previous types: the factor that the vertical lines must also vanish, creating an effect of depth.

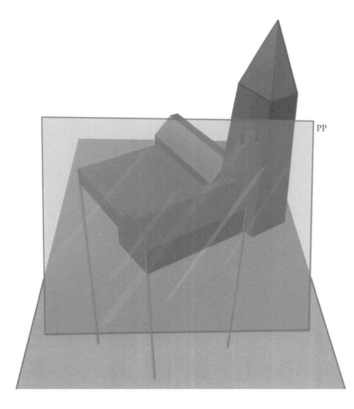

 Fig.2

From the observer's viewpoint the lines that are vertical in the object are not parallel, as in the other two types of perspective, but they vanish downwards. If we were to prolong these imaginary lines they would join at the third vanishing point of aerial perspective. As seen in this case, the walls of the tower are not completely vertical, but become narrower towards the top, their edges do not vanish towards the third vanishing point.

perspective: general concepts

Step by step

Box of watercolors

There are any number of subjects interesting enough to serve as a model in a perspective exercise. In fact we are surrounded by items with interesting shapes that we can paint. This exercise will be carried out using objects that are more than familiar to any watercolor enthusiast.

At first the fact that the box of watercolor paints does not have great height could confuse us and make us think that this is a case where oblique perspective needs to be applied. But because the arrangement is observed from above, aerial perspective is actually involved.

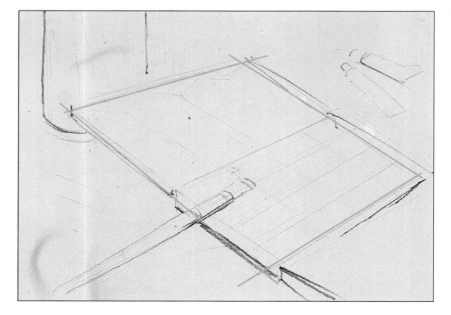

The first lines are sketched in a very general way: first the space to be occupied by the open box is established, taking care that the lines are drawn in correct perspective.

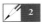

On the perfectly defined line diagram, the lines reinforcing the structure of the box are drawn. The fact that the paintbrush is positioned parallel to the box means that it must vanish in the same way.

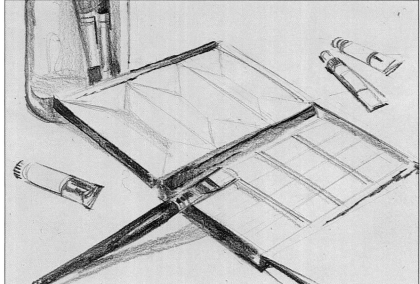

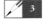

The forms of the composition have just been shaped with simple lines and with a dark tone that helps to define the shadow areas. The brightest lusters are left unpainted and the different compartments of the palette box are marked with bold strokes.

Step by step

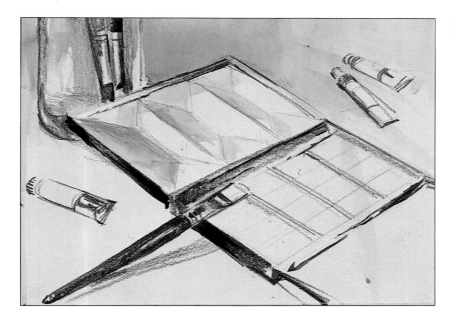

Once the drawing is completed, the necessary color may be applied. For the background we have used a very light violet tone. It is best if this tone is fairly cool (i.e. tends towards blue) so as not to spoil the subsequent effect of chromatic perspective.

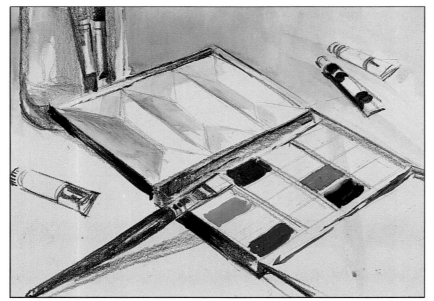

The bands of the watercolor tube in the top corner are painted in grayish-brown and blue. We are working with tube colors, which allows us to paint strong and luminous colors with hardly any mixing with water. The warmer and more saturated colors of the composition should be used in the foreground.

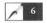

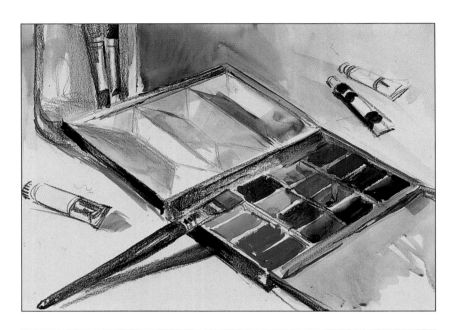

Before continuing with the colors of the palette, the background is darkened with a grayish tone produced by the mixture of various colors.

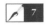

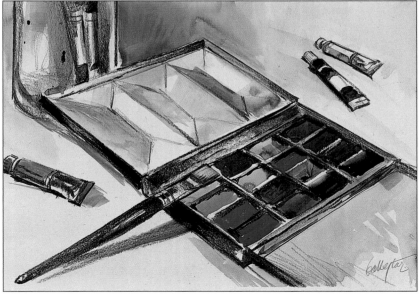

With one last brushstroke in black, the handle of the paintbrush on the palette box is darkened. It is better to leave the background a very dilute color, as applying it very saturated would flatten the image and ruin the effect of perspective.

perspective: general concepts

6. Counter perspective

Counter perspective is no more than a variant of perspective with three vanishing points, except that, in this case, instead of looking down the spectator looks up.

When we are at the foot of a very tall building and we look up to its highest point, we can see how the verticals converge in conformity with the increase in height. It is exactly the same as what happens in aerial perspective, except that, on this occasion, the third vanishing point, instead of being on the ground, is in the sky. As in the previous case, the picture plane is also tilted.

This incline is greater the more we raise our sight, so that, assuming we were looking straight up, completely vertically, the picture plane would be parallel to the ground.

The use of perspective with three vanishing points, in the cases both of counter perspective and of aerial perspective, can be enormously useful when expressing feelings.

Representing a scene or figure with a certain counter perspective gives a sense of magnitude and majesty.

The spectator is situated below the picture, both physically and psychologically. A building can give the impression of being enormous and a person can seem more important or powerful.

In the same way, but inverted, a scene represented from an aerial viewpoint appears more compact and insignificant.

These effects are frequently used in photography or the cinema to add emotion to the scenes and convey certain feelings to the audience.

Fig. I

Observation from a viewpoint that is low and very close to the object produces the same effect as in aerial perspective, but inverted. Now the vertical lines become narrower at the uppermost point, vanishing towards the third viewpoint, which on this occasion will be in the sky.

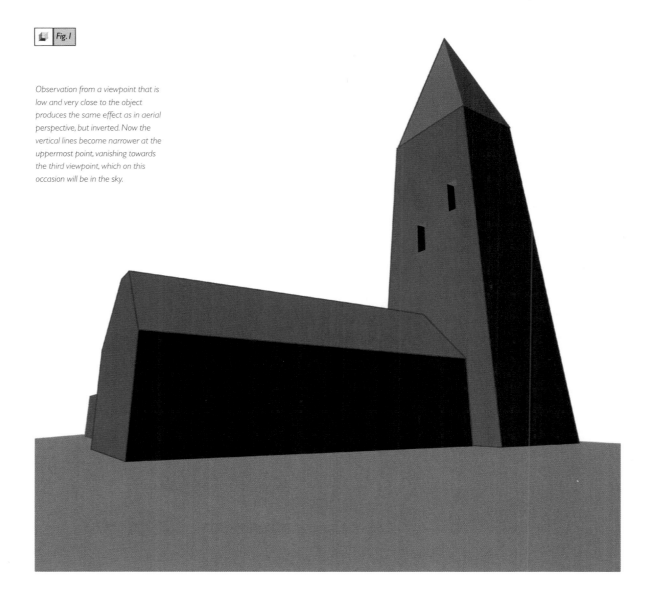

Perspect

e: techniques

1. Horizon

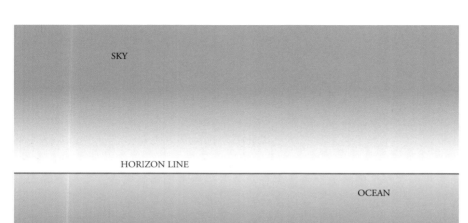

SKY

HORIZON LINE

OCEAN

BEACH

Fig. 1

The best example of the concept of the horizon is the natural horizon line, that we see when observing the ocean.

In drawing, the concept of the horizon is the same as that obtained when observing the ocean. The horizon line limits the spectator's view at its furthest limit. In many instances this line is imaginary and we should position it at eye level, taking into account another important concept, the viewpoint.

The viewpoint is the center of the angle of the observer's visual field, just in front of the observer. It is not above the observer's eye level, so the horizon line is always in front of the viewer, at eye level (*fig. 1*).

In drawing, the vanishing points are always situated on the horizon line.

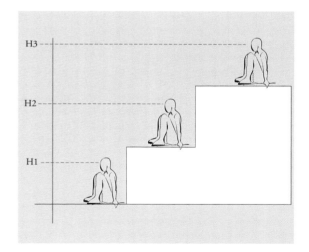

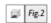

Fig.2

The horizon height is modified each time the observer moves or changes position with respect to the vertical. Three observers at different heights have three different views of the horizon line.

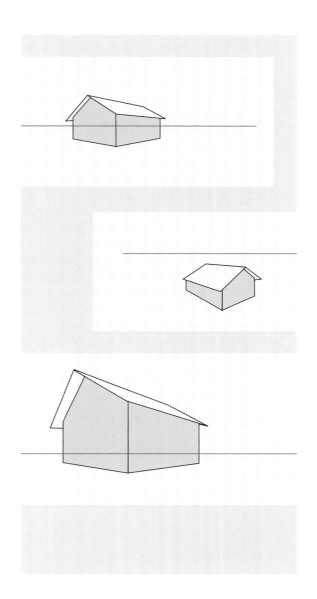

Fig.3

As can be seen in these examples, the same object, if shown with different horizon lines, appears in totally different ways. A low horizon line enlarges the object, while a high one reduces it. If we situate the horizon line at normal height, we obtain a balanced view.

Horizon heights

As noted previously, the line of the horizon should be situated at eye level. Therefore, its height varies according to the position of the spectator and also their viewpoint (*fig. 2*).

A low horizon line indicates a low viewpoint and, consequently, the whole view is similar to that of a small child. The buildings and surrounding objects are taller than us so their proportional size with respect to us will be exaggerated. This type of presentation is used especially to create a monumental or enlarged effect. A high horizon line, however, makes everything that is within our visual field smaller.

If our aim is to present a proportional view, we would ideally place ourselves in a position where our eyes remain fixed on the horizon line at a medium or low height, with respect to the buildings and the objects that we wish to include (*fig. 3*).

Determining height in relation to the horizon

Another factor that the artist should take into account is how objects are positioned with respect to the horizon line. Specifically, an object situated near the horizon line is not the same as one far away from it.

perspective: techniques

45

VP

Fig.4

The clearest example of this visual phenomenon are telegraph poles placed along a road. In spite of being the same height, we can see that they appear smaller and smaller as they near the horizon line and, thus, move further away from the observer.

Another example is that of a ship on the horizon. We know that the ship is larger than the little boat run aground on the beach, but its proximity to the horizon line makes it appear smaller.

Looking at a street in a town, the vanishing lines converge at one point (the vanishing point), which may be lateral (to the right or left) or central.

In this case the side walks, like the lines of the building facades, meet at the vanishing point in such a way that it is easy to see that the structures at the end of the street appear smaller in size, due to the effect of perspective.

If the structures in the distance appear taller than the buildings that are nearer, it is because the former are actually higher (fig. 4).

Fig.5

In counter perspective the horizon is frequently invisible, since it is situated way above the visual field.

Invisible horizon

In the case of a street on an incline, whether uphill or downhill, we need to refer to the invisible horizon.

In the case of the uphill street, the horizon line is below the vanishing point of the buildings, whereas the vanishing point of the sidewalks is on the same vertical but higher.

In the opposite situation, when we look down from the top of a street we can see how the lines of the sidewalks converge at a point vertically below the buildings' vanishing point, found on the horizon line, which this time is above.

There are other instances of invisible horizon in counter perspective and in aerial perspective.

If we observe an object far above our eyes (counter perspective), the horizon line remains outside our angle of sight, although it continues to exist. In this type of perspective, all the lines that would appear horizontal if we looked at the building face on (windows and cornices) converge in this horizon line which would remain outside the drawing. The same occurs if we look down from a great height as in an aerial perspective.

Step by step

Landscape is the best test area for experimenting with the horizon height. In this case we have placed the horizon very high, so the sky is reduced to a small strip of blue color. This is because we have located ourselves on the side of a mountain, looking at its summit. Consequently we have considerable space available within which to show the different areas that give depth to a picture. Owing to the rockiness of the landscape, we will use embossing paste.

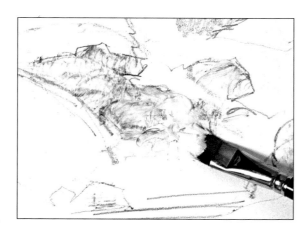

 1

The picture is composed with great precision, indicating each of the landscape planes. We will apply paste to imitate the texture of the rocks, in order to achieve a relief effect. A granular and detailed texture is applied to this entire area.

 2

Embossing paste is also applied to the hill that can be seen at the back, just up to where the trees begin in the background. The whole hill is painted in a green tone mixed with white to give the feeling of depth. The greens that are applied in the foreground will be purer than those painted in this area. When the hill has been painted green, the embossing paste is completely covered.

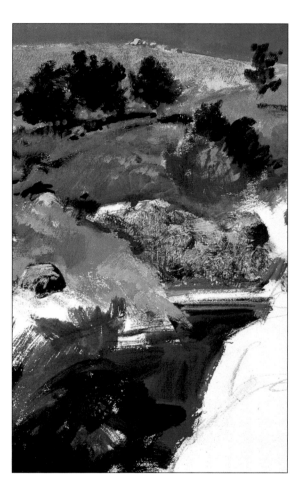

3

Texturing of the rocks is begun in the same way that texture was applied to the hill in the background. We paint, first with a dark gray color, then, once this is dry, with a somewhat color-stained paintbrush in an almost white tone, revealing the ridged texture of the rocks. The trees in the background are painted in very dark green tones. In the lighter areas green is mixed with yellow to achieve the appearance of drier grass. Where the grass is more luxuriant, the green color is made darker.

4

In this landscape it is very important to obtain a wide range of greens to ensure an effective feeling of depth, which is further reinforced by the base texture. The light parts of the tree on the rocks are painted in a medium green; these brushstrokes should be short and thick. The water underneath the rocks is painted in a greenish tone obtained by adding orange ocher to green. As can be seen, there is greater color contrast in the foreground compared with the areas further back, which have more color harmony.

Step by step

Colors and contrasts

Dusk presents us with a magnificent opportunity to do work on the sky and, consequently, on the horizon line. In this particular case, the horizon line is at a low level, so we have a great deal of space in which to deal with the sky. Situating the horizon line at a higher point would have greatly limited the main element of a sunset, which is the sky. We can see that the sunset used as a model here has highly evocative, color-rich tones of orange and red.

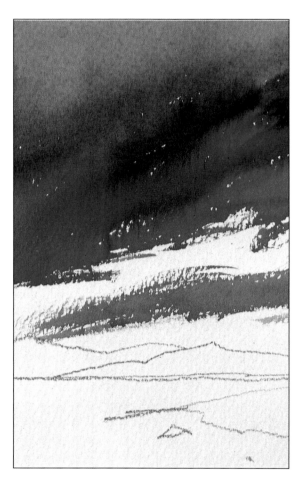

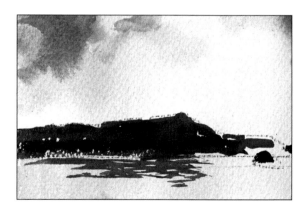

This time we see a horizon line which, while not as low as in the adjoining example, lets us depict the clouds in a suitable manner. Thus, we can also see their reflection in the water.

 1

First a very watery violet color is painted. Below is a complementary color and, in the lower sky, another strip, of orange. With this combination of colors we can provide the chromatic richness that this subject demands.

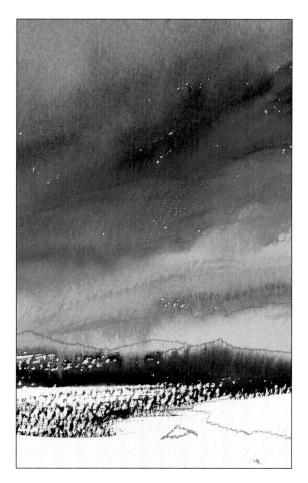

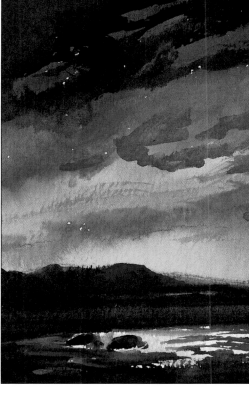

 2

 3

Cadmium red is applied on top of the orange colors of the sky. Finally, the ground above the water is dotted with spots of light.

Yellow ocher is painted on top of the orange, the central section taking on this color.

2. Perspective of inclined planes

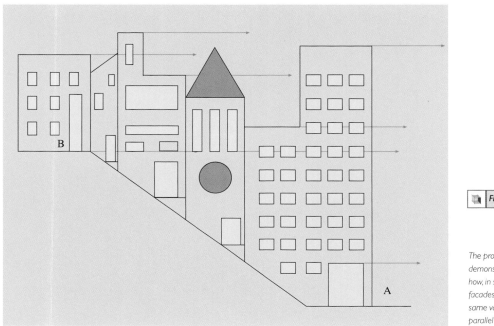

Fig. 1

The profile of a sloping street demonstrates, via the red arrows, how, in spite of the incline, all the facades of the buildings have the same vanishing point as the parallel perspective.

Until now, everything that has been explained regarding perspective, both parallel and oblique, has referred to vertical or horizontal planes. We must not forget, however, that in geography and, indeed, in all structures that human beings build, thousands and thousands of inclined planes exist that do not correspond to any apparent perspective.

Here we will go back to what was explained about the invisible horizon in the Horizon chapter, as what occurs with inclined planes is exactly the same, but we will also apply it to parallel and oblique perspectives, with their particular properties. In any case, it is important to note that, in spite of the slope of the street, the buildings remain parallel with the main vanishing point and the horizontal straight lines, but not the verticals, vanish because they are perpendicular to the picture plane (*fig. 1*).

Beginning with **parallel perspective**, we will take as an example a street with a steep slope (*fig.2*). Depending on where we position the viewpoint, the slope will be uphill (A) or downhill (B).

We will start with the uphill slope. Note that the position of the viewpoint is low, which is why the horizon line is below the slope. The lines

of the pavement of the uphill street are ascending and their vanishing point is located above the horizon line. This is also on the same vertical as the vanishing point of the horizontal straight lines, that is, the lines of the building facades, which is the original vanishing point of parallel perspective.

In order to precisely locate the higher vanishing point, the inclined plane should be viewed from the side and through a parallel plane, which will reveal the point on the vertical where the slope ends (*fig. 3*).

Now for the viewpoint. If we are at the top of a street with a steep downhill slope, we can observe the following: the vanishing point of the sloping street remains below the horizon line, although, yet again, on the same vertical as the vanishing point of the straight lines parallel to the horizontal plane. As in the previous case, a side view is needed to establish the correct location of this virtual vanishing point (*figs. 4 and 4.1*).

We move on now to **oblique perspective** and how inclined planes are represented in it. Even outside painting, this is one of the most represented subjects of all time: pitched roofs, the typical roofs of houses in the country. First of all we look at the plan and elevation of this house, with its simple lines of construction. Of course, these will depend on the viewpoint taken (*fig. 5*).

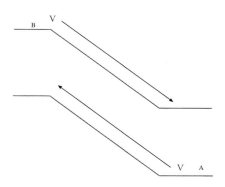

Depending on the viewpoint of the observer, the vanishing point will either be uphill, point A, or downhill, point B.

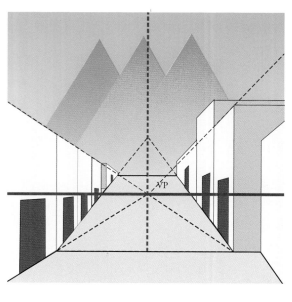

When we see a sloping street from its lowest point, that is, when we look uphill, the horizon line of the buildings is below that of the street.

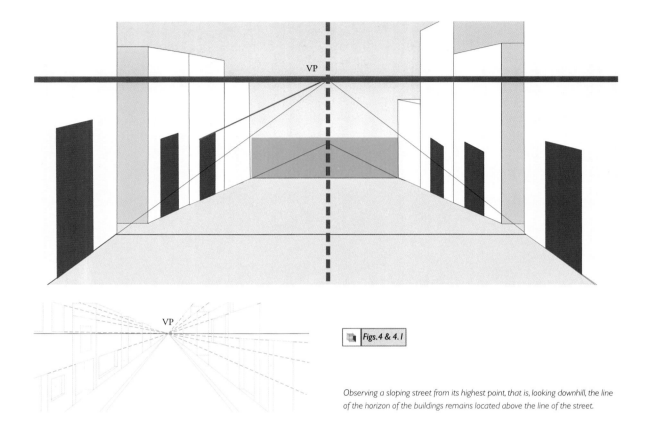

Figs. 4 & 4.1

Observing a sloping street from its highest point, that is, looking downhill, the line of the horizon of the buildings remains located above the line of the street.

In principle, the procedure is the same as with a simple form, like a cube. The difference is that, when positioning the inclined planes of the roof, we must not forget that we are applying perspective, so we must have vanishing points. The roofs are not parallel to any of the lines, so we can deduce that each slope has its own vanishing point, in other words there are two vanishing points. The question however, is where they are positioned.

Points A and B are located in the same facade of the building, but belong to different slopes. We will use these two points to explain what happens in this type of case. If the points are on the same plane, they must have the same vanishing point, so a line drawn perpendicular to the horizon line passes through vanishing point 1. One side of the roof will incline towards vanishing point 3 and the other towards vanishing point 4 (*fig. 6*).

 Fig.5

Here are the plan and elevation of a building with a pitched roof, showing both the viewpoint and the position of the vanishing points. If the observer stands more to the right, the roof's auxiliary vanishing point will be at VP1, whereas if they stand more to the left it will be at VP2.

Fig.6

In order to avoid problems it is best to remember this basic rule: The auxiliary vanishing points always remain on the vertical of one of the principal ones, one above and the other below.

Basically, you need to remember that one vanishing point is below the horizon line, while the other is above, and they are always on the same vertical as one of the original vanishing points of oblique perspective.

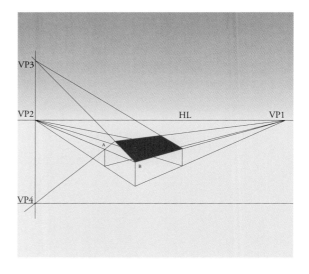

Step by step

Unlike modern buildings, the old houses normally found in villages do not very often have a clear profile with perfectly orthogonal angles and edges. It is more likely that you will find slopes, imperfections, bumps on walls, inclined roofs, and generally complex forms. This, on first sight, can appear to present difficulties when doing a perspective exercise, as it prevents us from being guided by clearly defined directions. However, in spite of the flaws that the image presents, if we know how to use the vanishing lines, and make an effort to adjust the proportions, the result is a great wealth of forms and the subject turns out to be a pleasure to paint.

In this type of work, intuition is very important, as there are a great many elements that we cannot draw in a more mathematical way. We should compare proportions and try not to lose the basic vanishing lines that tell us whether the rest of the elements are correctly located. In addition, the complexity and irregularity of the forms have the advantage of allowing a freer sketch that is less restricted by the original, as any possible errors made are less obvious than in a picture of modern buildings with more precise lines.

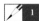

The penciled outline of the scene has a vast amount of detail, but we must take care not to include more information in the diagram than is necessary, only what is needed later to apply the color to a firm base. So, for example, there is no need to sketch in great detail the bricks and irregular stones that cover the walls. As the scene is observed in slight counter perspective, we can see that the verticals of the facades do not appear completely parallel, but converge at an imaginary point in the sky.

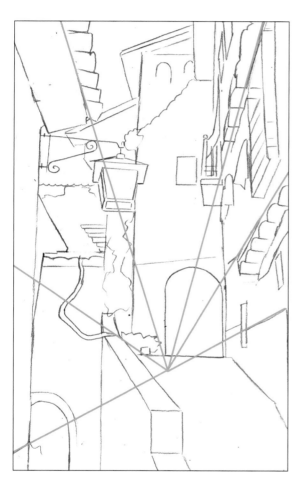

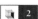 **2**

As we can see in this diagram, in spite of the complexity and irregularity of forms, we are dealing with a simple parallel perspective with a vanishing point situated at medium height. If we disregard the slope in the foreground, the horizontal elements of the houses converge at that point.

 3

The lines of the slope forming the part of the street in the foreground do not converge at the same vanishing point as the rest of the composition. This is because the incline of the street combines with the direction of the perspective. If the ground plane on the slope is not parallel to the ground plane in the remainder of the composition (and, by extension, to the horizontal elements of the houses, such as moldings, windows, etc.) the vanishing lines will also not be parallel.

Step by step

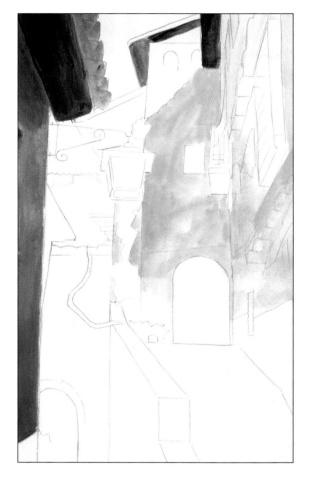

 4

This work will be done in gouache, a material that produces both a lighter, watercolor-type finish and another thicker one. We begin by adding color to some general elements such as the facades of the houses. The houses located in the foreground should have a stronger and more saturated tone, whereas those further away can be treated in a more subtle way with a more transparent layer of color.

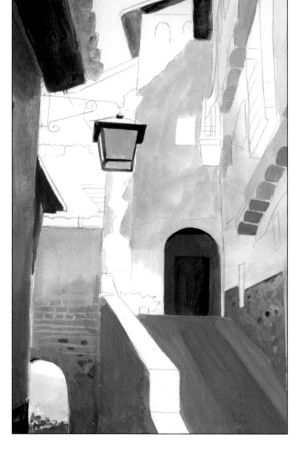

 5

In this composition, the light falls directly onto the houses in the background, whereas the foreground remains in shade. This is why it is important, while still adding general patches of color, to maintain the appropriate proportion of dark and light in each area.

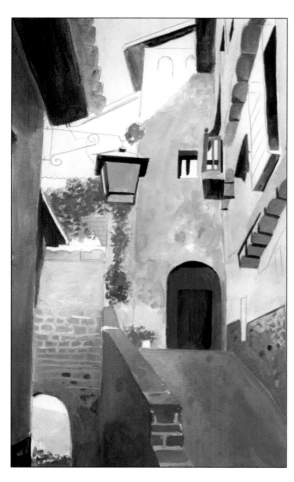

 6

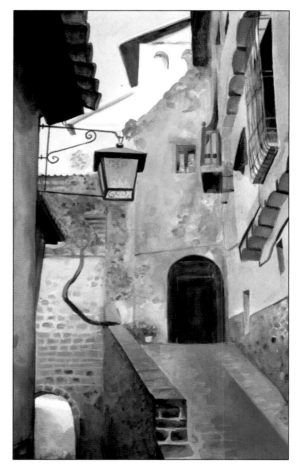

 7

Details such as the texture of the ground and the walls must be visible only in the closest parts of the picture; the areas furthest away should be less detailed since they would overload that part of the composition and would be counterproductive in suggesting depth. The paint is applied more thickly and in more saturated colors in the foreground than in the rest of the scene.

We have applied color to the linear structure. Details such as moldings, bricks, leaves, etc. can be included in the chromatic structure. The complexity of form referred to previously offers numerous opportunities for detailing in the method desired. It is always important, however, to control the amount of information that is included in the picture, because excess detail in all areas would result in a flatter image.

perspective: techniques

3. Orthographic projection

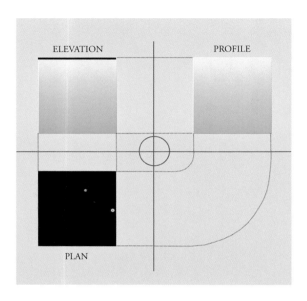

ELEVATION | PROFILE

PLAN

The three most characteristic views of an object are the elevation or front view (top left), profile (top right), and plan (bottom left). A relationship is established connecting these three points through perpendiculars.

When examining a particular object, with exact measurements, it is useful to study it from several viewpoints which give a precise idea of what you are trying to depict.

What these three viewpoints have in common is the fact that they are visible when the piece is situated at right angles with respect to the GP, the PP, and the spectator in orthogonal projection (ortho is a Greek word which means right-angled or perpendicular). These three viewpoints are: elevation or front view of the

object, profile, and plan (*fig. 1*). From these three positions the true dimensions of the object are established. In other words, we can see its shape exactly as it is and without distortion by perspective. This therefore gives us a clearer idea of what object we wish to place in the compositional space.

The cube in perspective

When explaining a system of perspective, it is always advisable to refer to an example, in order to visualize and fully understand exactly what we are talking about.

Consequently, when approaching different perspectives we will take the simplest three-dimensional shape, which is the cube. Using this shape as a key spatial example, we will first of all deal with the following:

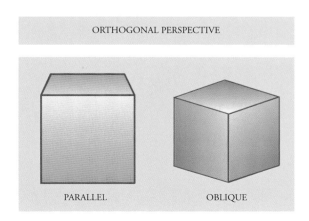

ORTHOGONAL PERSPECTIVE

PARALLEL | OBLIQUE

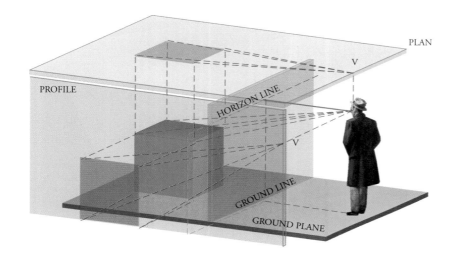

PLAN

V

PROFILE

HORIZON LINE

V

GROUND LINE

GROUND PLANE

 Fig.2

Parallel perspective

This type of perspective is much less real than oblique and aerial. On occasions, however, it is clearer. There is only one vanishing point and the lines that do not vanish in the space remain orthogonal, that is, they form perpendiculars with the ground plane or the picture plane.

Therefore, the object's true dimensions are always obtained when it is observed from the front, in profile, or in plan.

The best way of understanding all this is to look at the illustration (*fig. 2*), in which an observer is placed facing the picture plane, which is perpendicular. The cube has also been placed with the observer on the straight line that runs through the center of the cube's side and is perpendicular to the picture plane. In the same

illustration we can see that the plane perpendicular to the picture plane determines the outline of the cube in profile; at the same time a higher horizontal plane (what we will call the plan plane), has been placed parallel to the ground plane, where the view of the upper side of the cube is projected.

We are now going to explain, step by step, the method for working out parallel perspective for a cube, with the paper taken as the picture plane:

1. Sketch the elevation of the cube, the horizontal line of the PP (at the distance desired, when positioning the PP in front of the observer) and the observer's V, below the GL.

2. Join the key points of the figure, which are the four corners, with the V and mark the points where they cross the PP.

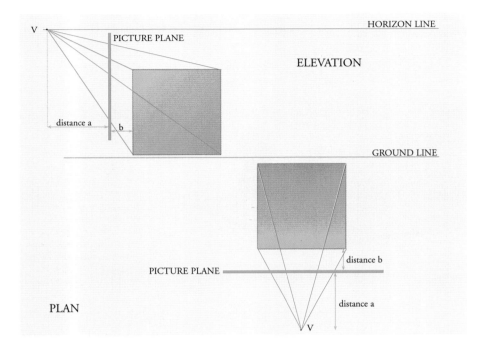

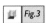
Fig.3

In order to determine the shape of the cube in perspective from its plan and elevation (or profile) projections, we will place the V at the same distance from the projections and the picture plane (distances a and b). The horizon line must of necessity pass through the V of the elevation. The lines directed at the corners of the cube projections are shown. The line perpendicular to this PP is drawn again at the point where it crosses the PP.

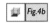
Fig.4a

The straight lines in the figure on the right join up and the shape of the cube appears.

Fig.4b

It is important to check that the lines n and m are the only ones either not parallel or not perpendicular to the PP. The VP will appear immediately after the lines n and m on the HL.

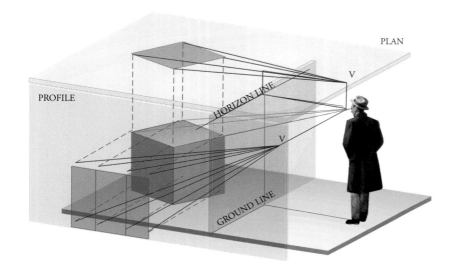

PLAN

PROFILE

HORIZON LINE

V

V

GROUND LINE

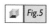
Fig.5

Oblique orthogonal projection of the cube. The difference between this and Fig. 2 is that the object to be represented appears on the GP, not parallel to the PP that the observer has in front of him.

3. In the top left-hand corner again place the V and the cube on the GL. Also, position the PP line, only this time perpendicular to the GL (*fig. 3*).

4. Placing these two views on the same sheet of paper, try to look for a relationship between them. This is obtained by extending the lines that start at the different intersections of the picture plane with the perpendicular lines emerging from the V, to touch the two views.

5. The lines perpendicular to both PPs intersect in space with those from the other view, producing a series of key points on the new cube already in perspective.

6. All there is left to do is to join these points (*fig. 4a*) and find the VP, as in *fig. 4b*, which is done by extending the two straight lines that form the new side (which gives the impression of perspective).

These straight lines (n and m, which are the vanishing lines), in their turn and in contrast to the rest of the straight lines in parallel perspective, are not perpendicular to either of the two PPs.

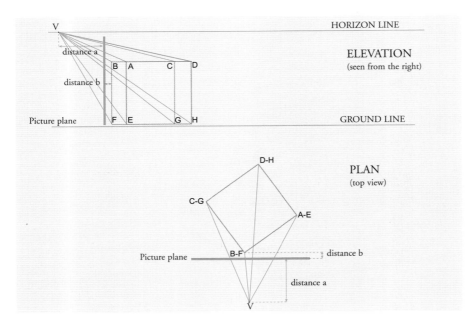

HORIZON LINE

ELEVATION
(seen from the right)

GROUND LINE

PLAN
(top view)

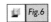 Fig.6

Picture plane

distance b

distance a

Carry out the same operation as in the previous step by step points (figs 3, 4a, and 4b). It is important to remember that the distances from the figure and from the V to the PP should be the same in the two views (elevation and plan).

Oblique perspective

One of the clearest differences between oblique and parallel perspective is that with the former many more lines will appear that are not parallel or perpendicular to the two PPs.

This is caused by the fact that oblique perspective precisely positions the base of the object obliquely, disrupting the parallelism with the ground line. This can be seen clearly in *fig. 5*, where the rotated ground has created a series of distortions in the final image. Another difference is the appearance of two vanishing points.

First of all draw the ground line and the horizon line, including the V. It is important to maintain the relative distances between the

PP and the V and the corresponding square (elevation or plan), as we can see in *fig. 6*.

The steps are the same as those taken to obtain the previous object in parallel perspective (*figs 3, 4a, and 4b*). However, a great number of lines appear, which require careful attention when forming the figure in perspective (see *fig. 7*).

After you finish check whether the figure has been drawn correctly by extending the perspective shape's lines that are in direct contact with the ground, to find the corresponding vanishing points (VP1 and VP2). We can see this in *fig. 7*.

In the bottom left-hand corner of this figure there is an explanatory diagram of the points

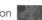

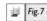

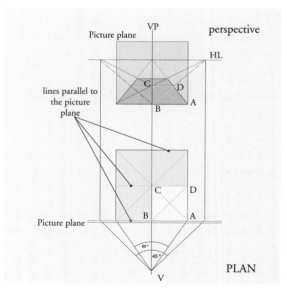

Fig. 7

It is advisable to check that there are two vanishing points (VP1 and VP2), which are situated, as always, on the horizon line, and what the results are of extending the vanishing lines of the object in perspective.

that make up the final figure, so we can see which points are left behind and which not.

In the real world, objects are often not positioned parallel or perpendicular to eye level (see *fig. 8*), but oblique perspective can resolve these views in a fairly convincing manner.

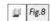

It can be clearly seen that the square of the plan view is parallel to the picture plane.

4. The circle in perspective

The topic of the circle in perspective can help us to appreciate and understand a little better how the system of perspective with vanishing points works. However, if what is required is a quick sketch, in this chapter a simple and practical, though not highly precise, method of completing a circle in perspective is also explained.

Drawing the geometric form of the circle in perspective is the simplest method if the figure is clear when observed in plan, that is, the top view and its plane (the view from above). The depiction of the circle here is in parallel perspective (inscribed in the square).

We begin this exercise with a square, which we can now draw in parallel perspective. The circle (drawn with a compass) is inscribed inside this square, as we see in *fig. 1*. Then the square is drawn in perspective, which will give the circle depth. We then simply locate two points on the circle (A, B), which we also know are in perspective.

These two points are insufficient to draw a circumference (see *fig. 1*), which is why it is necessary to find four other points. We can find these very easily, by drawing diagonals in the square on the plan. Now it is necessary to find these same points on the projection in perspective. This is done as shown in *fig. 1*, by drawing the diagonals in both squares.

Center of ellipse Center of circumference

 Fig. I

To obtain a circle in parallel perspective, place the circle inside a square in elevation. (By putting the square into perspective we will obtain the circle in perspective.). A very common error is to think that the center of the ellipse that is drawn once the circle is in perspective will correspond with the center of the square in perspective. Here we can observe that this is not necessarily the case.

Next, the points of intersection between these diagonal lines and the circle are taken and carried to the line of the PP and from there towards the VP. We can find each of these points (point B) at the point where they intersect with the diagonals that we drew in the square in perspective. We can see this illustrated in *fig. 2*.

In this way, when the two points (A, B) are found, the shape obtained, when the complete circle is drawn in perspective, will be that of an ellipse. It is preferable to try to look for more points, which is why we will repeat the process of looking for a point on the plan and later finding it inside the square in perspective (*fig. 2*).

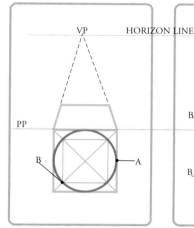
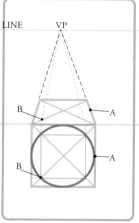
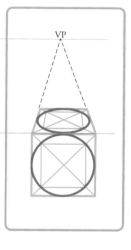

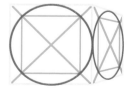

The key points and diagonals of the circle are positioned and then transferred in succession to the square in perspective.

It is also very important to note that the center of the circle does not correspond with the center of the ellipse in the drawing (*fig. 2*), since the circle drawn in perspective will continue to be a circle, although the eye may perceive it as an ellipse.

At the beginning of this chapter we mentioned that there was another much more practical method for those artists who have to draw the circle in perspective more quickly. This simple method is based on the observation that the outer square with the circle inscribed within it has four diagonals stretching from the center to its corners. If these diagonal lines are divided into three equal parts from the center to the corner (4 points total), there appears a point where one of the four points that also belong to the circle can be drawn fairly accurately in perspective (*fig. 2*). In the same way as just explained, we then proceed to search for and draw the parallel perspective of the square

with its two diagonals. We can then locate the four key points and draw the circle in perspective, as can be seen clearly in *fig. 2*. In *fig. 3* we can see how the same method is used to determine the circle in oblique perspective.

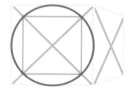

The same operation can be carried out with the lateral sides of the cube. In this case the ellipse corresponding to the circle will be vertical.

5. The cylinder in perspective

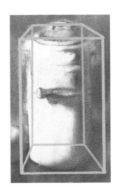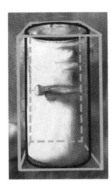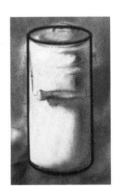

 Fig. I To demonstrate the process of drawing a cylinder we will use a container of milk. It is essential to establish the shape of the cylinder by placing it inside a rectangular box, in order to obtain precise measurements. We can see how the ellipses (the cylinder's bases, in perspective) are fitted into the rectangular box. Lastly, the yellow lines that made up the box are rubbed out and the cylinder becomes clear .

Once we have learned to draw circles in perspective correctly, we can begin to tackle simple geometric shapes that contain circles, like the cylinder. The characteristic feature of the cylinder is that its two ends are equal circles positioned in parallel. Therefore, its profile, the figure's elevation, does not have a particular number of surfaces or sides, but rather a continual curved surface, the perimeter of the circle. This outline, when vertical, is depicted by drawing only the outermost lines of the height of the cylinder.

The key to drawing a cylindrical object correctly is to use the perspective of a rectangular prism, in which the cylindrical shape is established.

Based on the previous explanation of the method for drawing a circle in perspective, the reader should be able to obtain the shape of the cylinder's base. Next it is necessary to draw the opposite base, which, of course, will also have to vanish towards the same points from its different position in space. Then these two bases or sides must be joined to the vertical lines tangent to both circles, as is noted in *fig. 1*.

One of the main errors normally appears at the junction point of the bases, as there is a tendency to believe that the point where the perpendicular straight line defining the side of the cylinder should start is the major axis of the ellipse. The point that should be used to position the straight line that forms the vertical outline of the cylinder is that point of the ellipse which is furthest out (*fig. 1*).

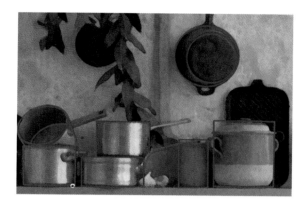

 Fig.2

In this group of still life objects we find numerous cylinders as the basic forms. It is important to note that not all are exactly cylindrical, if the two bases are not the same, but the method for drawing these figures in perspective is the same.

In everyday life there are many things with a basic cylindrical shape, from a glass to a bottle, a cake, or the trunk of a tree. When tackling subjects such as still life, it is especially important to have a clear method for correctly depicting the cylinder. In order to check whether you have fully understood how to depict a cylinder in perspective, it is advisable to try sketching a still life incorporating various cylindrical forms several times in the same space. You will observe that, according to the viewpoint used, the bases of the cylinders will appear as more or less closed ellipses.

A cylinder can be placed in different positions, some of which seem to complicate its depiction, such as an oblique perspective (*fig. 3*), but to resolve this all we need to remember is to draw the box in its correct spatial configuration and then the circles that will form the cylinder bases. The ellipses corresponding to the circles in perspective ought to be clearly drawn inside their respective squares, which are also in perspective.

In this matter it is very important to be completely clear about what type of perspective is being used: parallel, oblique, or aerial. Therefore, the circle of each base will be inscribed in a different perspective square, according to whether it has one, two, or three vanishing points (*fig. 3*).

 Fig.3

When separating out the basic shapes of the two objects in this still life, we can see the ellipses forming the edges of the figure on the left and the cylinder (in the now familiar case of the figure on the right) that appears in aerial perspective.

perspective: techniques

Step by step

Still life, from composition to detail

For this step by step exercise we will focus our attention on the cylinder. It's a good idea to choose a still life arrangement. Here the composition of forms is our main objective. We will work from the general to the particular.

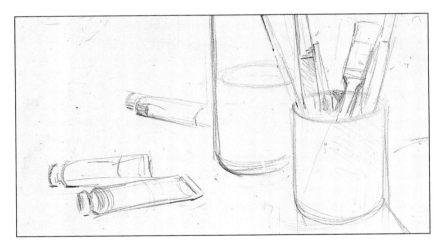

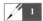
1

All the forms are sketched in pencil, enclosing the objects within a frame that brings them closer to the spectator. Part of the bottle is not drawn, which suggests the continuity of the picture. The left profile of the bottle is situated right in the center of the paper: from this line the rest of the elements are incorporated into the composition, in which the principal components and the main emphasis are moved towards the right. The tubes of watercolor allow us to maintain a compositional balance.

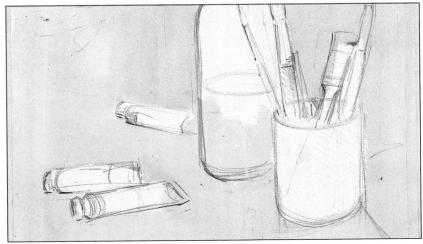

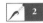
2

Begin the picture by painting a large patch of yellow color. This wash is prepared on the palette and is applied to the paper very quickly, without allowing the edges to dry before applying successive brushstrokes that cover the whole of the background. Note how the color is applied to indicate the principal volumes of the picture: take care to leave blank the areas that will shine.

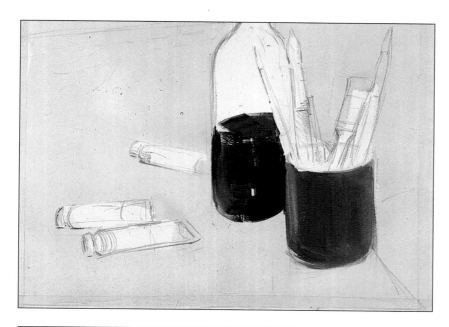

Wait until all the color applied in the first glaze is dry. The colors subsequently added are thick and almost opaque. The forms are interpreted as large and generous patches. First, a sienna mixed with a trace of carmine is applied to the bottle on the left. After rinsing and drying the paintbrush, part of the color is taken away from the most luminous area. The pot on the right is painted with the same technique.

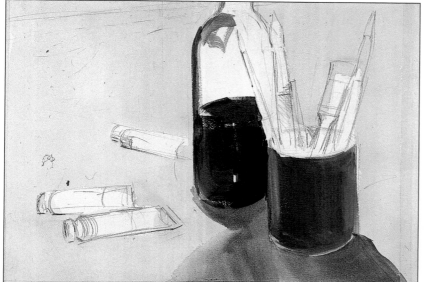

A green brushstroke is applied on the tablecloth. This will be the bottle reflection; with one single very luminous patch of cobalt blue and sienna we can finish painting the shadow. A sienna colored brushstroke is applied to the side of the bottle to establish its profile. Before it dries, begin applying the green color, take part of the color from the line. In the green paint, the white is now left blank, corresponding to the shine.

Step by step

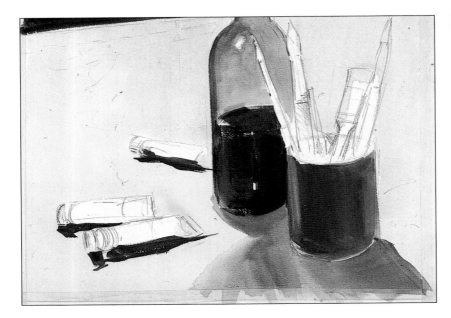

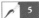

The green color of the bottle has just been painted. It is much more opaque in the area on the left and absorbs part of the sienna line on the side. The shadows of the tubes of watercolor are fully defined with blotchy brushstrokes: this line draws at the same time the patch of the shadow and the tubes (which have still not been painted).

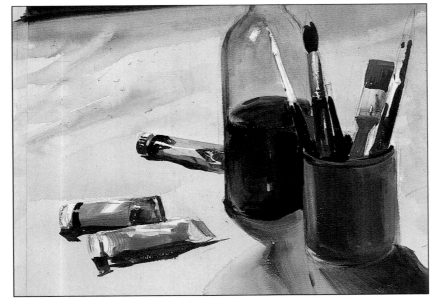

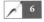

The tubes are taken care of with a few patches of ocher; here the volume of the objects has to be perceived via the shine, which is no more than the blank background of the paper. The main tones of the brushes are applied without the need for any more volume than that provided by the shine. A grayish color is achieved with a mixed tone of blue and sienna, which is watered down until a transparent glaze is obtained. The whole background of the tablecloth is painted with this color; the most luminous points are left light, whereas in the shade of the folds the contrast is increased slightly.

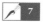

The body of the bottle has just been shaded with a dark glaze; finally, the form of the brushes is detailed with dark tones. Note how the yellow tone in the foreground stands out with respect to the glazed tones in the background. The variety of light and shade help to express the cylindrical shape of the chosen objects.

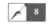

In this detail we can see that the forms of the paint tubes are based on cylindrical shapes.

6. Dividing depth into equal parts

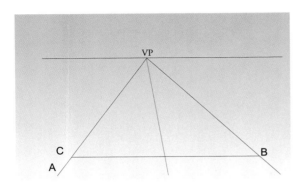

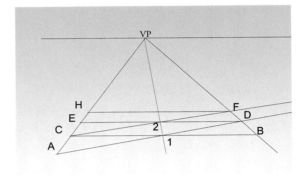

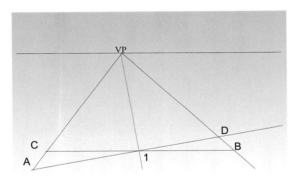

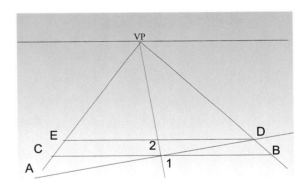

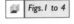
Figs. I to 4

Space is both infinite and unique. The question is how to represent it and how, from this, all the elements that are found in it are positioned.

Sometimes we can find ourselves in a situation in which space is divided into equal parts, for example with the uniform units of railroad tracks or the geometric segments of many buildings.

Here we will examine how these divisions are developed in parallel, oblique, and aerial perspective.

Here we can see the process of dividing a surface into a series of infinite parts. In this case the reflection takes place on the ground plane, but it could also be carried out on a vertical surface.

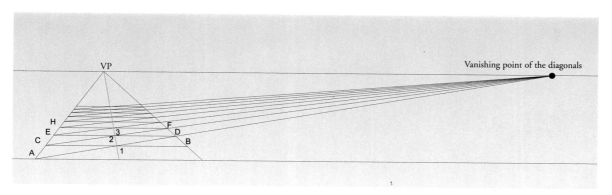

 Fig.5 *Because they are parallel straight lines, the diagonals converge at the same vanishing point just like railroad tracks.*

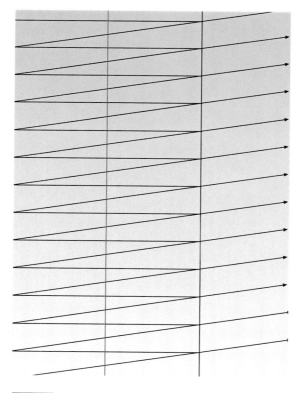

Fig.6

Plane representation of divisions along the surface. Here the diagonals of the quadrilaterals are also parallel.

Parallel

Parallel perspective basically depends on a horizon line, a vanishing point for all the parallel lines, and a viewpoint.

Let us take as an example railroad tracks, seen according to parallel perspective. First of all, in order to divide the space, we must position the horizon line and the central vanishing point. The rails are positioned from the edge of our paper to the VP on the HL. We will then divide the space between the rails into two equal parts with a red line.

For the next step, the horizontal divisions can be marked, as shown in *figs. 1* to *6*.

Now we can observe what happens when a vertical space in parallel perspective is divided: it could be a facade with windows distributed equally. Essentially the procedure is the same as that described previously. The difference here is

perspective: techniques

75

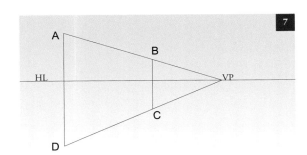

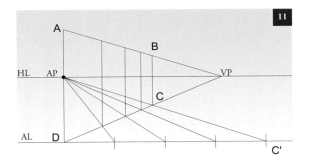

 Figs. 7 to 11

7. Here we have the surface, defined by the points A, B, C, and D, which is what we will divide into four equal parts.

8. The correct positioning of the axis line and the axis point is fundamental for the successful outcome of the exercise.

9. We can find the real axis by passing a straight line through point C up to the axis line.

10. Once the divisions of the axis line are made, they return to the relevant segment via a straight line from the division point to the axis point.

11. Starting from the intersections made, perpendiculars are drawn upwards to delineate the divisions.

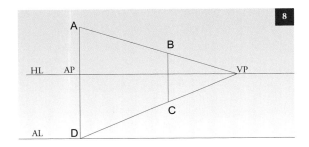

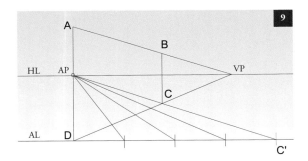

that, when the divisions are found in perspective, a perpendicular straight line is drawn up for each of them, as shown in *figs. 7 to 11*.

Oblique

In the case of oblique perspective, the space contains a horizon line but two vanishing points (*fig. 12*). We can explain this type of division with a simple example: the walls of a house covered with wooden panels of the same size. Once the walls of the house are drawn, we

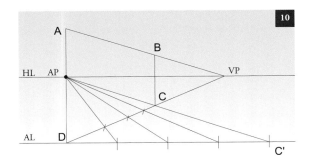

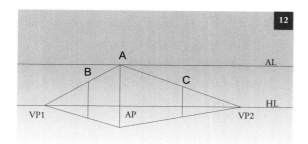

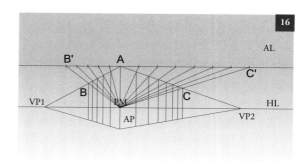

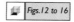

Figs. 12 to 16

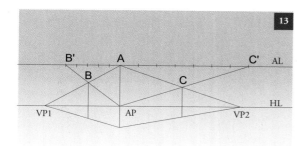

12. In a classical oblique perspective, we can observe two vanishing points on the horizon line. First establish the boundaries of the surfaces to be divided. Then position the axis line and the axis point. The axis point is on the intersection of the edge nearest to the observer with the horizon line.

13. To find the true segments, a straight line is passed through points B and C to find points B' and C'. These segments are divided into the relevant parts.

14. Each division is returned to its segment with a straight line that runs to the axis point.

15. We will be able to fix the points of division in perspective where they cross into the segment to which they belong.

16. From each intersection point a perpendicular is drawn down to the horizon line.

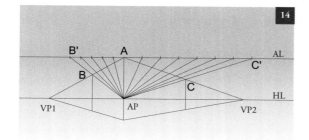

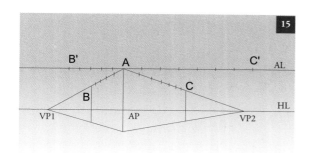

position the axis line (AL) and the axis point (AP) in the same way as with parallel perspective. This time, however, we will place them in the upper area so that both procedure methods can be seen. The axis line is made to pass through point A, one of the vertices of the edge nearest to us. The axis point will be at the intersection of this edge with the horizon line (*fig. 13*).

In order to establish the size of the segments A-B and A-C, straight lines are drawn from the axis point, passing through each of the points B and C, and on to the axis line.

So we now have points B' and C'. Once these new distances are established they are divided into equal parts, in this case five on one side and seven on the other (*fig. 13*).

In the same way as we did before with parallel perspective, each division is returned to the relevant segment, by drawing a line between the division point and the axis point (*fig. 14*).

We will be able to fix the points of division in perspective where they cross into the segment to which they belong (*fig. 15*).

In order to finish establishing these divisions, from these points we take parallel straight lines, perpendicular to the horizon line, down to the main edge (*fig. 16*).

Aerial

If the division into equal parts is made in aerial perspective, we must find out how volume is drawn in this perspective. Apart from the HL, there are three VPs: two on the horizon line (VP1 and VP2) and one outside for the vertical lines (VP3) (*fig. 17*).

The AL is positioned on the vertex nearest the viewpoint, which in this case is point A.

In order to position the AP we extend the edge that passes through point A until it cuts the HL (*fig. 18*).

The divisions are made following the same process as with the other perspectives. We draw a straight line that passes through vertices B and C as well as through the AP. Once these straight lines are extended we obtain points B' and C' on the AL (*fig. 19*).

Next, we divide these lines equally into the required quantity. Each point of division is joined to the axis point and, where these lines cross the relevant edge, we then have these measurements in perspective (*fig. 20*).

To finish, from each one of these points draw vanishing lines towards VP3, the vertical vanishing point (*fig. 21*).

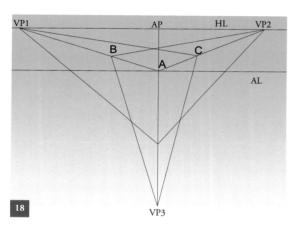

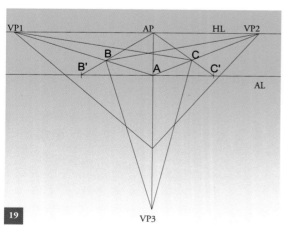

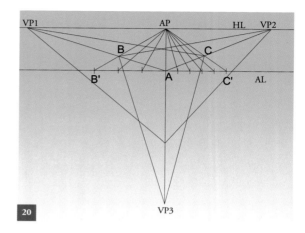

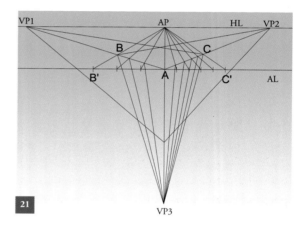

Figs. 17 to 21

17. In order to practice division into equal parts in aerial perspective, it is best to take a simple volume such as this parallelepiped.

18. We extend the edge that passes through point A upwards until it cuts the horizon line, which is fairly high up. In this way we find the axis point.

19. As in the previous cases, in order to find the true size of the segment we draw a straight line that passes through vertices B and C as well as through the AP. Once these straight lines are extended we obtain points B' and C' on the AL.

20. In order to find the projection in perspective, the divisions are returned to the segment with a straight line which unites them with the axis point.

21. The straight vertical lines are drawn, uniting each division point with vanishing point 3, the vertical vanishing point.

Step by step

Building in oblique perspective

Modern buildings present us with excellent subjects for perspective exercises as the external lines tend to be simple, without too many elements that would impede the procedure.

In addition, the orthogonal layout of a great many of these buildings considerably simplifies the perception of perspective.

For this step by step exercise we have chosen a view of a modern building in oblique perspective, that is, situated in such a way that none of its sides is parallel to the picture plane. We know, therefore, that we will have to work with two vanishing points, one on the left and the other on the right of the observer.

In this drawing we can see where the two vanishing points are positioned. As the artist is not very far away from the building, the perspective is rather exaggerated; for this reason, the vanishing points are not too detached.

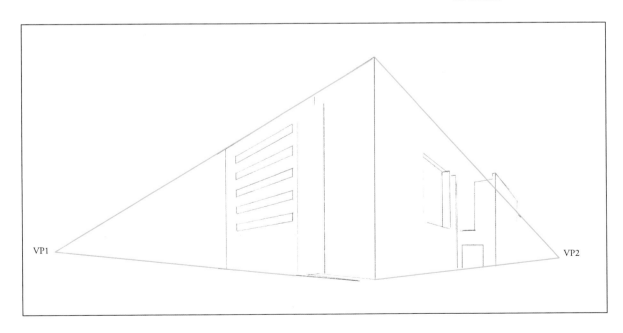

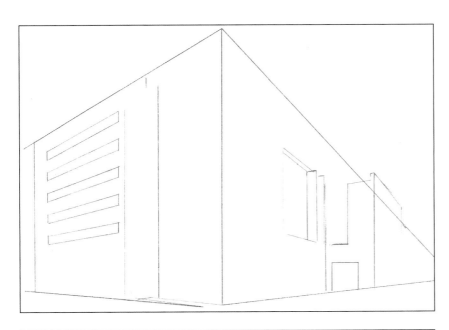

The major lines of this building are very simple. It is important to position them so that the perspective is correct. If these initial lines are drawn well, then we have already done most of the work.

Once the major lines are confirmed, continue drawing the rest of the elements, such as windows, doors, etc. This part of the process is not very complicated, as we only have to follow three guidelines: the two vanishing points and the vertical. This way, the horizontal lines of the elements that we wish to represent vanish to one vanishing point or the other and the verticals are all parallel.

Step by step

When dealing with a building in which white and light colors dominate, in order to make it stand out we need to use the contrast with the sky. Begin by applying a light blue base that will serve as a reference for assessing the tones of the building. As we are working with colored pencils, we know that it is difficult to lighten a color already applied. On the other hand, we can always darken the finished work. For this reason it is important to begin with a wash and then gradually darken afterwards.

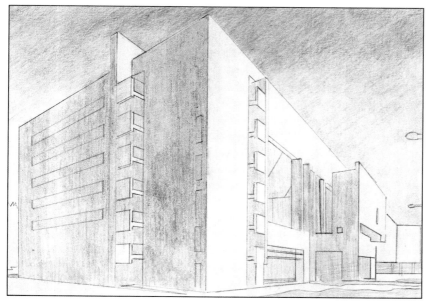

Among the tones of the building, two basic areas can be differentiated: that receiving direct light from the left and that in the shade. A good way of beginning to color it is to mark these two areas first of all. We do not use black pencil for this because the result obtained this way would be too neutral and boring. In order to color the shade we will superimpose a dark blue tone with a brown, as these two colors neutralize each other, producing a grayish tone in a variety of shades.

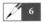

Once the general tones are established we can then apply color to the rest of the elements. The fact that very grayish tones are being used makes it necessary to pay special attention to changes in light and shade, otherwise we would end up with a very boring result. As can be observed, the bluish tone of the building is very different from that of the sky, the latter being much more saturated.

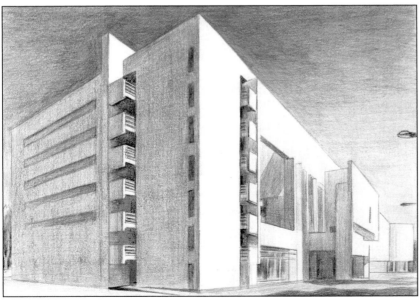

With a sharp pencil we finish defining the details and giving a stronger contrast to the darker parts. These contrasts must be emphasized in the areas that are more to the foreground, thus achieving a greater effect of depth. By intensifying the color of the sky at the top we also obtain a greater contrast with the intense white of the wall.

perspective: techniques

7. Periodic repetitions in perspective

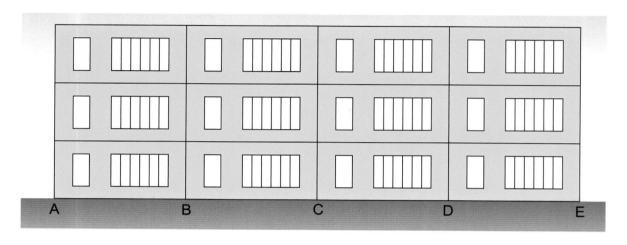

 Fig. I *In order to divide a surface with periodically repeated elements in parallel perspective, we make divisions on the axis line and position the relevant heights. It is a case of joining their corresponding points in order to correctly represent each one of the elements so that they do not appear distorted.*

The whole of this chapter is dedicated to periodic repetition of one or more elements along a facade, such as windows, doors, or balconies. In order to explain this method clearly, we will take the simple example shown in the illustration (*fig. 1*). You can see how the building, viewed from the front, is no more than a periodic repetition of the same elements.

We will consider the building as a whole and will construct it according to the rules of parallel perspective (*fig. 2*).

Then, we take the larger module as a whole, that is, the section from A to E, which is again divided into four parts. We position the segment A-E and then points B, C, and D on the axis line.

In this way we obtain segments A-B, B-C, C-D, and D-E, which define the four smaller modules (*fig. 3*).

We can then obtain the heights for the rest of the smaller elements. To do this we will position them on the edge nearest the observer and then take them up to the vanishing point that is on the horizon line (*fig. 4*).

Next, we place points 1, 2, 3, and 4 inside module A-B (*fig. 5*). Once these divisions have been made we connect these points to the axis point by means of a straight line (*fig. 6*). Then draw a perpendicular line to the line of the horizon for each of these points, 1, 2, 3, and 4 in perspective (*fig. 7*).

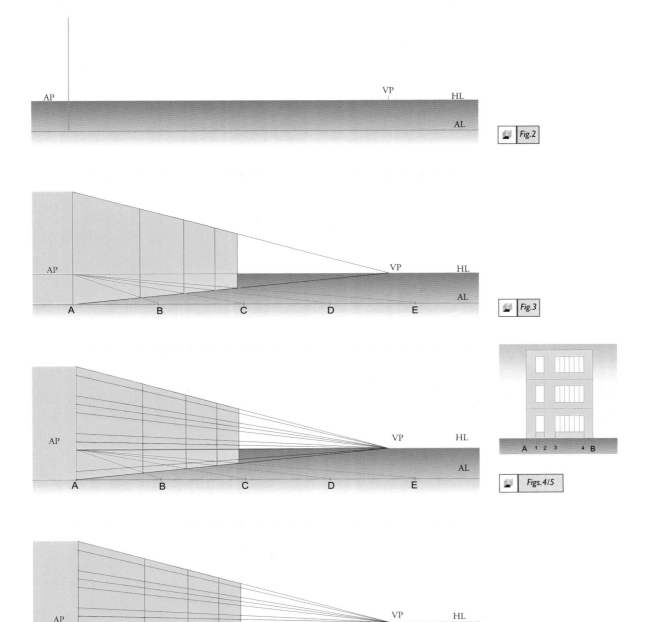

AP · VP · HL · AL · Fig.2

AP · VP · HL · AL · A · B · C · D · E · Fig.3

AP · VP · HL · AL · A · B · C · D · E · Figs.4/5

A · 1 · 2 · 3 · 4 · B

AP · VP · HL · AL · A · 1 2 3 · 4 B · 1 2 3 · 4 C · 1 2 3 · 4 D · 1 2 3 · 4 E · Fig.6

perspective: techniques

85

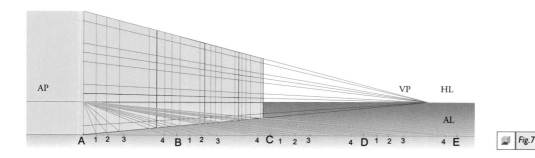

AP VP HL AL

A 1 2 3 4 B 1 2 3 4 C 1 2 3 4 D 1 2 3 4 E Fig.7

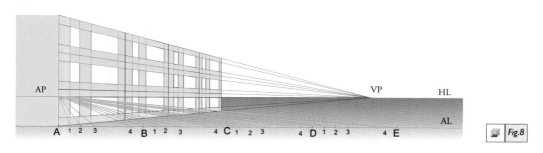

AP VP HL AL

A 1 2 3 4 B 1 2 3 4 C 1 2 3 4 D 1 2 3 4 E Fig.8

In conclusion, mark a point for each perpendicular that crosses the height in perspective and with these points mark each one of the elements on the facade (*fig. 8*).

We will now go on to consider oblique perspective. Two views are presented: elevation and profile (*fig. 9*). We begin by drawing both facades in oblique perspective, using the method we have already learned (*fig. 10*).

Then we place all the existing distances on the axis line, to one side of the corner or the other. That is, we insert the distance between the windows as well as the window measurement on both facades. We do the same with the doors (*figs. 11* and *12*). Immediately after, we join these

measurements with the axis point, and where they cross the line of the facade we place the points and, consequently, the measurements are put into perspective (*fig. 13*). From each one of these points we draw a perpendicular straight line to the horizon line (*fig. 14*).

We position the heights of the elements on the edge nearest the observer, as we did in parallel perspective. But on this occasion we have two vanishing points, so these measurements will vanish to both points, one per facade (*fig. 15*).

Where the lines of the vanished perpendiculars and heights cross, we can locate the points by which we can then define the smaller elements (*fig. 16*).

Fig.9

Fig.10

Fig.11

Fig.12

Fig.13

Fig.14

Fig.15

Fig.16

perspective: techniques

87

8. Use of guidelines

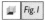 *Fig. I*

This picture shows how a parallel perspective can be achieved when the vanishing point is outside the limits of the paper.

Using guidelines is the artist's best system for maintaining the correct perspective and not distorting the elements that they are going to depict.

We may find on many occasions that what we want to represent is either too large or too close to be fully shown without going off the paper. In other words, when the vanishing points are situated outside our paper or material, we have to use guidelines. Briefly explained, guidelines are marks at the edge of the drawing of the vanishing direction of all the elements in the picture.

As always, we will need to make a distinction between oblique and parallel perspective in order to clarify the differences between the two methods. As shown previously, when we intended to create a drawing in parallel perspective, we would establish the defining elements. However, this time we can ascertain that the

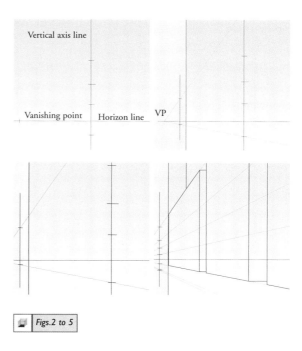

Vertical axis line

Vanishing point Horizon line VP

Figs. 2 to 5

2. These are the basic elements of parallel perspective: a HL, a vertical axis line, and a VP.
3. As can be seen in this diagram, the VP remains outside the drawing area.
4 Initially, establish the principal vanishing lines and take them up to the edge of the paper. Then the heights of the elements are placed on the vertical axis line.
5. The rest of the elements are made to vanish by eye, taking care that they are between both principal vanishing lines.

vanishing point is outside the paper (*fig. 3*), so we will not be able to represent it.

Next, we establish the vanishing direction of the principal lines and take them up to the edge of the paper (*fig. 4*).

We then establish the straight line that is closest to the observer and on this we mark the subdivisions of the architectural elements. Then, with the eye, we make them vanish, in the same direction as the two principal vanishing lines (*fig. 5*). The division points must lie between the two points that we have previously placed on the edge of the paper. Of course, these divisions will be proportionally smaller than those on the principal edge of the building. This is a simple way of establishing the vanishing point when it cannot be achieved in the standard way.

We now go on to see what happens when we use oblique perspective (*fig. 6*). In this case we will have two vanishing points but, apart from this, the procedure will be similar to that for parallel perspective.

First of all we determine the principal vanishing lines by eye and take them to the edges of the paper. In this case there will be two edges because there are two vanishing points, so we should take both directions into account. Next we proceed as with parallel perspective, establishing the segments on the principal edge, which is that closest to the spectator.

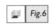 Fig.6

This is a picture of an urban landscape, in oblique perspective. We can see immediately that both vanishing points remain outside the edges of the paper.

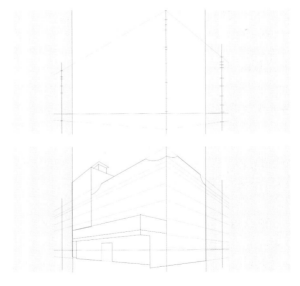

 Figs. 7/8

7. We establish the heights of the architectural elements from the principal edge, which is that closest to the spectator.
8. Once the elements have been made to vanish, we are able to see how these fall proportionally between the two principal vanishing points.

9. Stairs in perspective

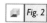
Fig. 1

As a result of perspective, the last step is smaller than the first.

We have decided to dedicate an entire chapter to stairs because they are one of the most common architectural elements, and therefore one of those to which perspective is applied most frequently.

We need not explain more than that a staircase is a periodic succession of steps. Here we see plan, elevation, and profile representations of a simple staircase (*fig. 2*).

We can appreciate that a staircase, like a sloping street, is basically an inclined plane. For this reason the observer's viewpoint is very important for the way the stairs are depicted, as is the method of perspective chosen to represent them.

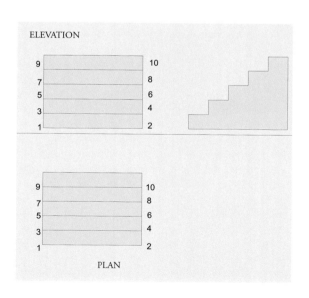

Fig. 2

Elevation and plan views of a simple staircase of five steps. Stairs are an essential architectural element.

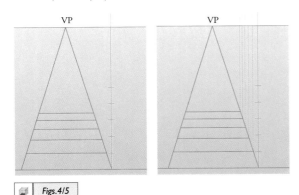

Fig.3

When we draw a staircase in parallel perspective we must remember how to divide a surface into equal parts.

Figs.4/5

Straight lines are drawn from the points nearest to the spectator in order to find the heights. It is also important to run a perpendicular line to the horizon line from the extremes of every step.

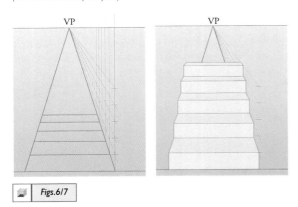

Figs.6/7

We draw each one of the heights to the vanishing point and in this way find all the points that make up the staircase.

Below is an explanation of how to draw a staircase in parallel perspective.

First, we must take into account that in parallel perspective heights diminish according to the vanishing point.

In a staircase seen from above or below, the vanishing point is the last step and is always smaller than the previous steps (*fig. 1*).

To start with, we take the width of each step and position it in the way explained in the chapter dedicated to the division of depth into equal parts (*fig. 3*).

Once the laterals and the width of the staircase are established, we draw a perpendicular line from one of the points to the horizon line and mark on it the heights of each of the steps (*fig. 4*). We also draw a perpendicular up from each of the horizontals (*fig. 5*).

The heights are drawn up to the vanishing point and where the perpendiculars of each of the steps cross them, the points for each step can be marked (*figs. 6 and 7*).

In oblique perspective, the procedure is similar to that for inclined planes. We must first determine the horizon line, an axis line, and vanishing points.

perspective: techniques

In addition, we also position the auxiliary vanishing points on one of the vanishing points.

We mark the equal measurements of the stairs on the axis line to both sides of point A (*fig. 8*).

From A we draw two straight lines that vanish to VP1 and VP2, respectively. We extend lines from the sections on the axis line (these correspond to the width of the stairs) to the axis point. On the points that we found previously (created at the intersection of the lines drawn from the axis line and the line to the vanishing points) we draw perpendicular straight lines to the horizon line (*fig. 9*).

We position the heights of the steps on the principal edge, which runs from point A and is perpendicular to the horizon line (*fig. 9*).

The step heights are established by means of straight lines to VP1. This occurs in this case

because the viewpoint chosen is seen from the right. If it had been any other viewpoint, the vanishing point would be VP2.

Where these vanishing lines cross the verticals, the points relevant to the steps are formed. This time we project the steps to VP2 (*fig. 10*).

In order to finalize the staircase, we take the points marking the measurements for the stairs' width and, where they cross the first step's vanishing line to VP2, we draw a point that we extend to VP1. Where this vanishing line crosses the following step's straight line, we draw a perpendicular up to the horizon line and repeat the action (*fig. 10*) as many times as there are steps (*fig. 11*).

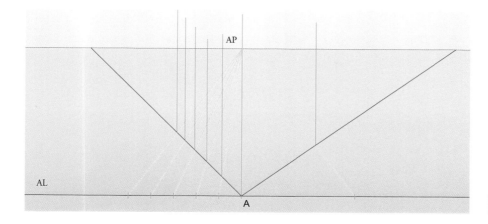

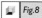 Fig.8

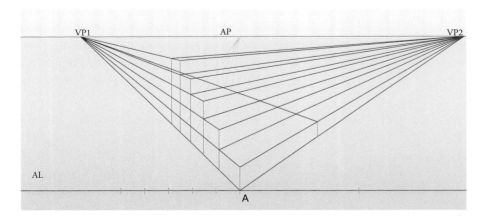

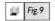
Fig.9

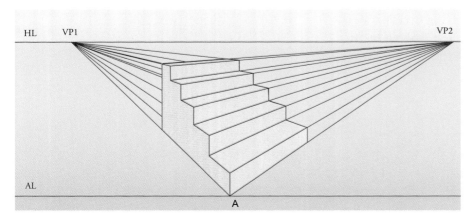

Fig.10

Fig.11

10. Shadows from sunlight

Shadows and perspective

For an artist, shadows are as important to the composition as the proportions or the sketch. By means of shadows, the subjects that the artist captures in the three dimensions of reality are modeled and transmitted to the two dimensions of paper and canvas.

Shadows are no more than the absence, to a greater or lesser extent, of light, but they depend upon many factors that will help us to classify them. In order to explain these light phenomena, we will use a figure, the volume of which, due to its characteristics, can be explained only through shadows: this is the sphere.

The first factor to be considered is the nature of the source of light. The light can be natural, like sunlight, or artificial, such as that originating from a streetlight or a lamp (*fig. 1*).

Another factor by which we can classify shadows is the direction of light with respect to the subject and the observer; this can be lateral, front facing, from above, or back facing (also known as against the light) (*fig. 2*).

Shadows can also be faint, penumbral, or uneven, where the form of the object is well defined (*fig. 3*).

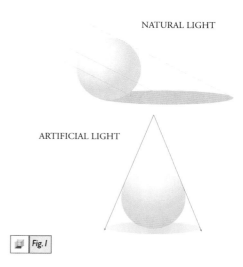

NATURAL LIGHT

ARTIFICIAL LIGHT

Fig. 1

The source of light can be artificial or natural. The difference is that the source of natural light is so distant that its rays are parallel to the ground, while the artificial source is fixed and known and the luminous rays are spread in a radial manner.

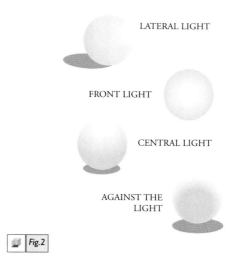

LATERAL LIGHT

FRONT LIGHT

CENTRAL LIGHT

AGAINST THE LIGHT

Fig.2

Depending on the relationship between the observer and the subject, there are four basic types of illumination: lateral, front, central, and against the light. In the case of front illumination, the shadow is behind the object, so we cannot see it, unless it is very long or our viewpoint is very high.

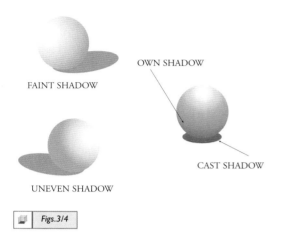

FAINT SHADOW

OWN SHADOW

UNEVEN SHADOW

CAST SHADOW

Figs.3/4

If the light source emits strong rays, the shadows will be very pronounced. If the light, on the contrary, is faint, the shadows will be faint as well. The object's own shadow is the one it casts on itself. The cast shadow is what falls on the vertical or horizontal planes, or both.

Aside from these factors, there are two basic types of shadow: the object's own and the cast shadow.

The object's own shadow is produced on the object itself when the light falls upon it. The cast shadow, on the contrary, is what appears on the floor, or other adjacent items, when the light falls upon an object. It is the shadow that the object casts (*fig. 4*).

Because they are an integral element of the drawing, shadows are also subject to the laws of perspective.

In the following sections, we will categorize shadows according to their source: either a natural source (or sun) or artificial sources.

Sunlight

Light from the sun is dispersed radially. The sun is so far away from the earth that the narrow angle of its light makes it appear parallel. Consequently it is often said that while artificial light spreads radially, natural light spreads in a parallel manner (*fig. 5*).

When the artist is working with the sun at their back, the subject is illuminated only at the front (*fig. 6*).

Let us take a shoebox as an example. If we place it on a table and we position ourselves opposite it with the sun at our back we will observe that both the shadows and the light rays appear to have a vanishing point. The shadows cast on the ground plane vanish in the same direction as the bottom of the box, whereas, if the shadow is cast on a vertical plane, like an adjacent wall, it vanishes in the same direction as the sides.

The vanishing point of the shadows (VPS) is on the same vertical as the vanishing point, or, in other words, the source of the light rays. In addition, the shadows' vanishing point is found below, on the horizon line, coinciding with the natural vanishing points.

In the example of the shoebox, we can observe that the side perpendicular to the light rays and the lid of the box are completely illuminated. The shadows also have a vanishing point

 Fig.5

The light rays from the sun are parallel when they reach the earth, although they started off radial. This is due to the great distance traveled.

on the same vertical as the light source and, in turn, on the horizon line.

Meanwhile, the shadow on the side opposite the front of the box and the shadow cast onto the table are deeper (*fig. 7*).

When the artist is working with the sun in front of them, this is called a position against the light. This leaves the subject illuminated in the area opposite the artist, who will capture only its silhouette. This is what happens with the object's own shadow. The cast shadow, however, is between the artist and the subject.

As in the previous case, we will take a simple shoebox as an example. In an against the light situation, the illuminated side will be that opposite the artist, whereas the front is in darkness with the shadow cast in front of it. The sides and the lid of the box would also be partially illuminated (*fig. 8*).

With lateral illumination, both the front and the back of the box become progressively darker

the further they are moved away from the illuminated area. Looking at the example of the shoebox again, we see that the amount of light on the sides is reduced from one end of the box to the other. The shadow cast will be disposed one way or another depending on the slope of the illumination (*fig. 9*).

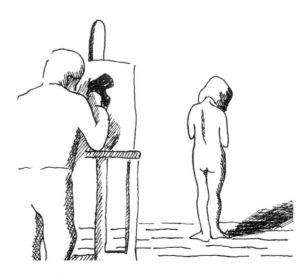

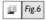 Fig.6

If the light source is behind the artist, the subject will be completely illuminated with the shadow behind it, so the artist will not see the shadow or will see it only partially.

VP1 VPS VP2

SUN

 Fig.7

The box's planes furthest away from the light source remain in total shadow, whereas those closer are perfectly illuminated.

SUN

VP1 VPS VP2

 Fig.8

Here we can see how the shadow cast runs towards the artist, in the opposite direction to the vanishing line of the box and the rays of light.

VP1 VP2 VPS

SUN

 Fig.9

Here, as in previous cases, we see that shadows vanish to a point on the horizon line and the rays of light are parallel. The shadow cast can be silhouetted where the vanishing lines of the box cross with those of the light.

perspective: techniques

Step by step

Front door

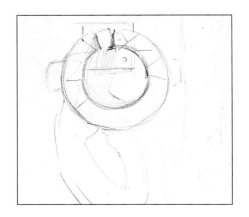

Begin this exercise with a sketch. Drawing a subject such as this does not require great skill, but it is crucial to know how to depict the circles of the doorknocker. Once the doorknocker has been drawn, we sketch its shadow on the front door. Here the light strikes from above, and the shadow cast on the door is almost completely underneath the doorknocker.

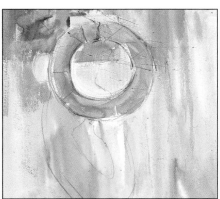

We apply an initial wash on the whole background, using very transparent, almost liquid colors. Begin with an orange ocher, and while the paint is still wet incorporate patches of blue which blend into the background. Wait until the background wash dries. In the top left we deepen the tone with some broad brushstrokes of sienna. Note that in this application of color we use the brush to outline the piece of metal on the door. We use the same color to paint the doorknocker but much more transparently.

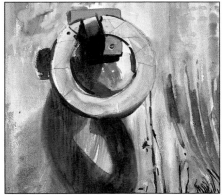

The background color serves as a base for new glazes, which are now applied with a medium brush in order to have better control of the drawing. The colors that appear more blurred are applied after dampening the background. We paint the shadow of the doorknocker but note that part of the color is blended with one of the new brushstrokes. With long brushstrokes of sienna we begin to form the texture of the wood. Lastly, we paint, in very dark brown, the contrast made by the doorknocker's shadow. We increase the contrast in the bottom right corner, first of all with a reddish glaze mixed with dark brown; then we use blue and sienna for a very controlled darkening of the background. When this last application is dry, we draw the grain of the wood with a paintbrush that produces a fine line.

On the left we apply some brushstrokes of ocher mixed with sienna; this color affects the lighter tones, but takes away some of the color from the shadow of the doorknocker. We begin to paint the ironwork; the pierced metal produces shadows which we paint as dots. Now, with the same color as these dots but much more diluted, we outline the area corresponding to the shine. Be careful to leave the shine unpainted and in the background color. Over the whole left hand side of the picture, we darken the shadow and the contrasts with a very dark brown, on top of which we emphasize some of the woodgrain.

First of all we paint the doorknocker with dots until the whole surface is covered and we draw the fine lines that divide it into triangles. Let's review the whole painting process and the different layers and glazes applied so far: first, apply approximate colors and the background tones, then define the contrasts and, finally, add the details which allow all the previous color applications to be distinguished. With a fairly dry paintbrush we begin detailed work, in dark brown, on the texture of the wood: small lines and patches that provoke subtle contrasts with the area previously textured. These do not necessarily have to be large patches, but small brushstrokes that enrich the lines of the grains and knots.

The texture of the background is enriched in very specific areas. We increase the contrast between the reddish tones and add some new contrast with black. Using a wet paintbrush, we blend the new tones and the background. The use of shadow often has the additional effect of adding greater clarity to the image through contrast. As can be seen, if it were not for the shadow projected on the door, the colors of the door and the doorknocker would be confused. The final picture shows how the combination of drawing and painting, enhanced by knowledge of shadow perspective, gives rise to a very realistic image. Note that, as in the majority of cases, the shadow projected by a circular object has an elliptic form.

 # Step by step

In an urban landscape we see the effect of perspective very clearly not only when trying to depict buildings. The vast majority of urban structures are built orthogonally in relation to the street plan. In this arcade a very marked perspective can be seen in the pillars and the metal framework; also, we can see that the shadows that the framework projects on the ground are an important part of the image and contribute to expressing the effect of depth. This scene is an example of parallel perspective with the vanishing point displaced to the right.

This scene may strongly remind us of works from art history where the top of the composition is closed by means of domes and arches. A few such examples were discussed at the beginning of this book.

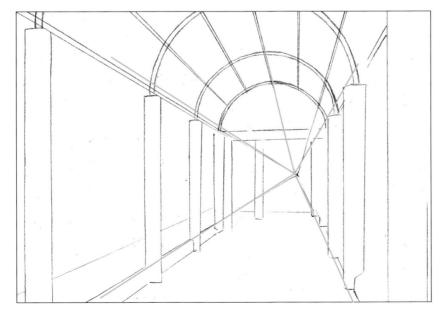

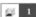 1

Using graphite begin arranging the image, positioning it in the correct perspective. It is better to begin with the architectural-type elements in order to create a framework to which the rest of the details may be added later on. The vanishing point is the most important reference and should be taken into account when calculating the height of the pillars.

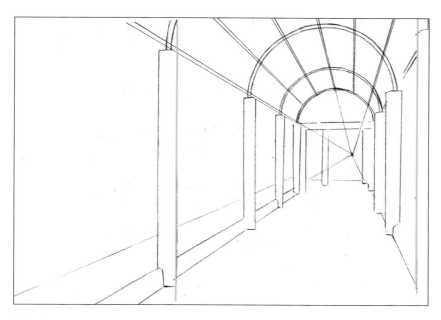

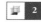

When a work of perspective is based on a photograph, it sometimes seems as if the scene is presented at an incline, as in this image. As we can see, the pillars are not completely vertical, giving a greater dynamism to the picture. This is an interesting option worth considering.

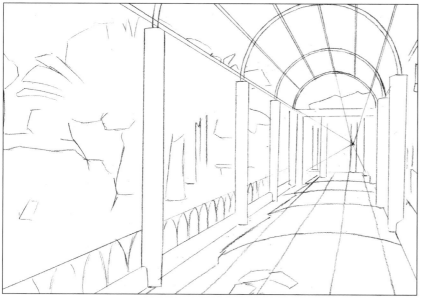

Once the structural elements of the architecture are correctly positioned, the vegetation and the most important shadows can then be subtly incorporated. The drawing must be suggestive, with the paper only lightly marked with the graphite, as we are going to paint with watercolor, which is not opaque and the lines could show through.

Step by step

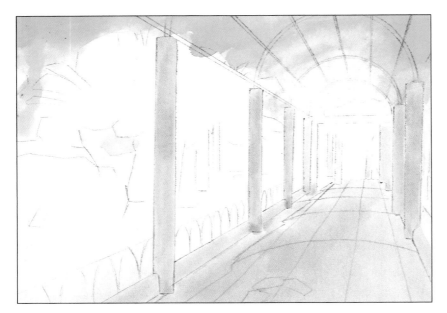

Begin painting with the blue tone of the sky, applying a wash without worrying about covering the framework of the arches. These will be a darker color and you can paint on top of them. Also, a general tone is applied to the floor and the pillars, which will be blended later on, in keeping with the other colors of the composition.

For the vegetation a general green tone is applied with a very free hand. The leaves on the palm trees add great expressiveness to the picture. It is advisable to deal with all the vegetation at the same time rather than finishing it bit by bit, in order to give it greater unity.

Greater intensity is given to the green patches in the foreground in order to reinforce the perspective. It is not necessary to draw every leaf, but to use lines to suggest the plants. The buildings to the right in the background are left simply suggested to maintain an effect of distance.

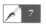

Finally the framework of the arches is painted in a dark color, taking care that it is finer the further away. The shadows projected on the ground enhance and enrich the composition. In addition, the shadows of the pillars provide volume and realism. Finally paint the rest of the details like leaves, textures of grass and stone, etc.

perspective: techniques

11. Shadows from artificial light

As explained in the previous chapter, all light, whether natural or artificial, is disseminated radially and in a straight line. However, through the effect of distance, natural light is considered to be parallel instead of radial. This does not occur with light that originates from an artificial source such as a lamp.

In addition, artificial light is usually stronger than sunlight, since the source is closer to the object. For this reason, the shadows are usually harder and present problems with the tone and color of objects.

To understand this concept, think of a light bulb. The light coming from it is disseminated radially. Therefore the further away objects are placed from the source of light, the more parallel and separated their rays will be. This confirms that the shadows caused by artificial light are different from those produced by sunlight. Rays from artificial light are bigger and their projected form is different from the natural light rays, although in many other aspects they are identical.

The same tools are used to give perspective to shadows whether artificial light or sunlight is involved. We know that we use a vanishing point for the shadows, but for artificial light the light's source, unlike that of the sun, is known and movable. For this reason we can refer to a specific point (*fig. 1*).

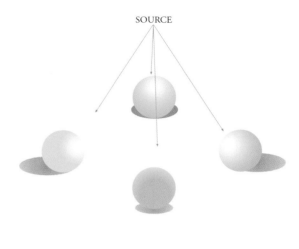

SOURCE

 Fig. 1

Artificial light is clearly disseminated in a radial manner. By placing four spherical objects under an artificial light we can see that the shadows go in four different directions. This is the opposite of what would happen with natural light, where they would all go in the same direction.

This concept may seem confusing but can be better explained with the help of a simple example like that of the shoebox.

First we must note the direction of the light and make sure it passes over each one of the box's corners before reaching the ground. The point where it crosses the vanishing line of the shadows is where we find the shadow cast by the box. The box's own shadows remain within the lines in the direction of the light (*fig. 2*).

In the event of having more than one light source, which is a common situation inside a

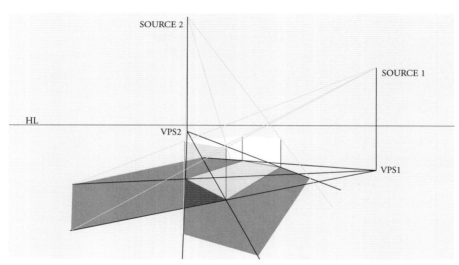

 Fig.2

Both the artificial light source and the vanishing point of the shadows are situated under the same vertical. In this case, the vanishing point of the shadows is not above the horizon line, but on the ground plane.

 Fig.3

If we have more than one source of light, we will have two areas of lighter shadow and one darker one in the area where these two cross.

studio or any other interior scene, we see that the shadows created by these sources can be quite unusual. As we mentioned already, the vanishing point of the shadows lies beneath the artificial light source. This means that we will have as many vanishing points for the shadows as there are points of light in the room.

If we observe the shoebox lit by two light sources, we will see that the edges of the shadows are much more diffused, softer than when the box is lit by only one light source. We can also observe that within the area of shadow cast by the box there are different tonal values. The outer shadow will be a penumbra and will be lighter than the area where the shadows cross, which is called an umbra. The umbra area is the darkest part of all the shadows (*fig. 3*).

perspective: techniques

12. Shadows on inclined planes

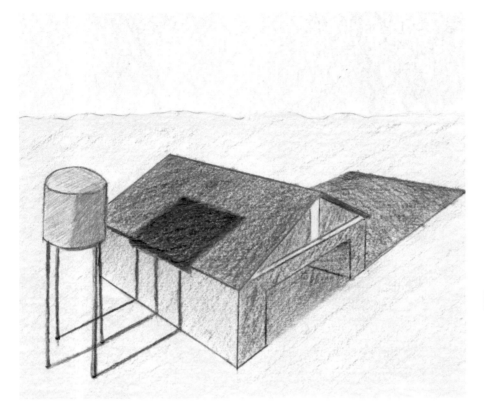

Fig. 1

When we are representing the urban landscape it is normal to come across inclined planes and shadows produced from them.

Usually, shadows are produced on inclined planes (*fig. 1*).

The object that generates the shadow does so from the ground plane or from the same inclined plane if the object is positioned on an incline. An example of this is the chimney on a roof.

The type of shadows will depend on the inclination and the position of the sun or of the light source. If the light is very high up, the shadow cast will be short and the contrast between the illuminated area and the object's own shadow will be great (*fig. 2*).

If the sun, on the other hand, is in a low position, as at sunrise or sunset, the shadow an object casts will be very long. (*fig. 3*).

Finally, the shadow will be the same length as the object that produces it if the angle of incidence of the sun is 45° (*fig. 4*).

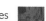
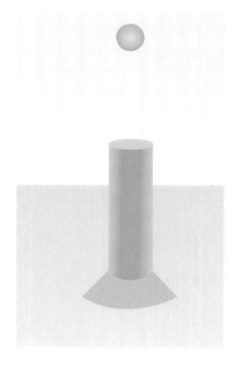

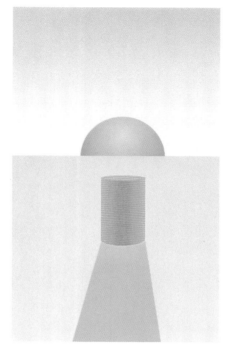

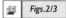 Figs.2/3

*If the sun is high the shadow cast
will be very short, almost imper-
ceptible, while the object's own
shadow will be in strong contrast.
If the sun is in a low position, as
happens at sunrise or sunset, the
shadow is very long.*

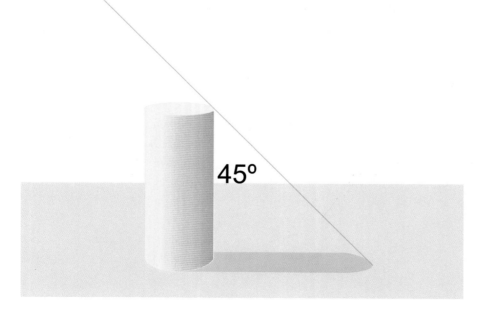

45º

 Fig.4

*If the sun's rays fall on the object at
an angle of 45°, the shadow cast is
the same length as the object.*

perspective: techniques

13. Reflections

Objects reflected in water and in a mirror

One of the most common problems for the painter, either of landscapes or interiors, is the depiction of reflections. These arise on surfaces that, because of the material comprising them, are capable of reflecting what surrounds them: the water in ponds, lakes, and puddles, or mirrors, metal and polished surfaces. There are countless examples from the history of art illustrating this optical effect (*fig. 1*).

The depiction of reflections frequently cause a problem for the inexperienced artist. One always tends to think that reflections are produced equally on either side of the line separating reality and reflection. But this is not true: the duplicate is not exactly the same as the original object.

The reflections produced on the surface of water can be many and varied, since they depend on several factors: the movement of the water, the quantity of light, and the inclination with respect to the surface.

The reflection of an object, then, depends on the inclination and its direction (*fig. 2*). If an object is inclined towards the observer, the reflection will lengthen in such a way that it will appear with a more stylized silhouette. The

 Fig. 1

The Arnolfini Marriage *(1434) by Jan van Eyck. Observe how the artist uses the mirror as a stylistic resource and applies the perspective of the reflection.*

greater the inclination, the greater this elongation. There is a point, however, beyond which the reflection disappears, because the reflection keeps the same direction and angle as the object to which it belongs.

If the inclination of the object is going in the opposite direction from the observer, the reflection will be short.

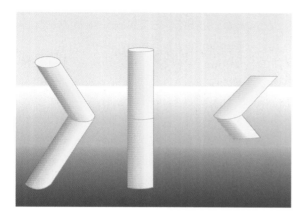

 Fig.2

The reflection of an object inclined towards the observer increases its length with respect to the original. If the object is perpendicular to the reflective surface, the length of the object will be maintained. If, on the other hand, the object is inclined away from the observer, its reflection will be shorter than itself.

If, on the other hand, the object remains vertical, the reflection will be exactly the same length as the object.

Another important factor to keep in mind is that if the surface of the water is not calm, the reflection will be broken up (*fig. 3*). The nearer we are to the object, the larger and more broken the reflection will appear to us.

On the contrary, when we move away from the object and its reflection we will see that the breaks in the water become fewer and smaller and the reflection is seen as one entity beside the object.

 Fig.3

If the water is in motion the waves break up the reflection and so it is lengthened.

 Fig.4

If the reflected part of the object is illuminated, its reflection will not be as clear as if it is shaded or dark.

We have already noted that reflections depend on the type of light. A very strong reflection is due to the fact that the sun or the source of light is shining from the opposite direction. When the reflected part is in shadow, the reflection can be seen more clearly, as occurs, for example, with the hulls of boats that are painted black or a dark color. The opposite happens when the reflected part is illuminated: the reflection is more subtle (*fig. 4*).

To continue with our study of reflections in water, we can examine a well-used example that artists frequently depict because of the beauty of its composition: bridges. The constructive ingenuity of human beings has given rise to the creation of various types of bridges throughout the course of history and the countries of the world.

In depicting different bridges there is one verifiable, if obvious, fact: the reflection of a bridge shows its underside, so that the reflection is comparatively larger than the bridge itself (*fig. 5*). This happens equally as much in parallel perspective as in oblique perspective.

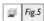 Fig.5

This bridge, depicted in oblique perspective, has a reflection that is larger than the original, as it also reflects its underside.

 Fig. 6

In a room reflected in a mirror, we can see how the reflection is produced laterally.

The reflection in a mirror occurs in a different way, since it normally reproduces all the elements seen on the other side in their entirety. In parallel perspective, the objects are reversed laterally, that is, whatever is on the right appears on the left and vice versa. But whatever is above stays above, and whatever is below stays below (*fig. 6*).

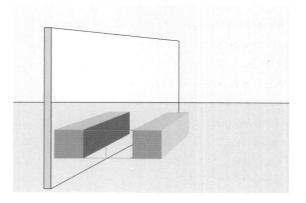

 Fig. 7

The distance between the object and the mirror is the same as that between the edge of the mirror and the reflection. This is a product of the lateral effect.

perspective: techniques

Step by step

<div align="right">

Marina

</div>

Marine views are usually quite suitable for painting with techniques like watercolor, since it allows the lightness and transparency that this type of subject usually requires.

One aspect of the painting of marine subjects where perspective is most evident is in the depiction of reflections. One must bear in mind that reflections have their own rules and that, furthermore, they follow the rules of perspective of the objects that they reflect. If you've followed the suggestions from the previous chapters and your depicted reflection is not too complex, you should also consider paying attention to other factors, such as tone and chromatic intensity.

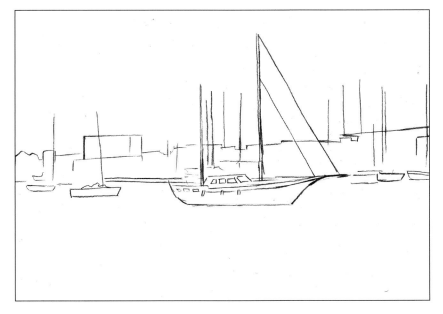

At first the broad forms of the boats are arranged and the buildings in the background are suggested only lightly. This is a composition in which horizontal and vertical lines predominate, conveying a strong feeling of stability. In the pencil drawing it is not necessary to include the reflections, since these are simple enough to be produced directly with a brush and in this way we avoid the lines showing later underneath the watercolor.

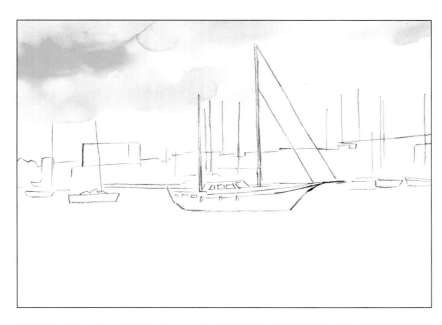

The sky receives a highly diluted paint wash. The spontaneous way in which the watercolor is applied to the paper is appropriate, since it imitates the effect of the clouds. It is best for this first application of color not to be too dark, because in the final picture it must be the area of maximum luminosity.

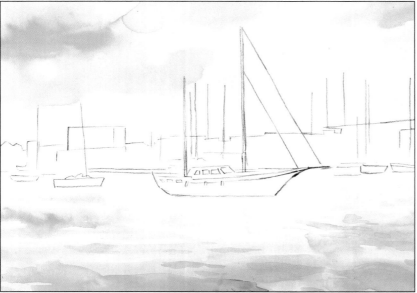

The sea is treated in a similar way to the sky, except that in this case a darker tone of blue is applied. The waves take on a definite shape through lightly undulating brushstrokes that allow the paper to shine through in certan areas. The lowest part of the composition has a greater tonal contrast, since it is the nearest to the spectator.

perspective: techniques

Step by step

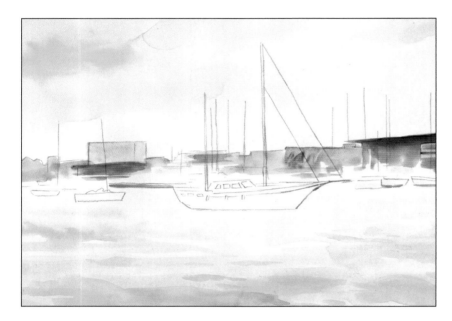

For the buildings in the background, light variations of browns and greenish tints have been applied very lightly. We do not want these to have too many color contrasts or too much detail, since they are situated in the most distant part of the composition. Additionally, this would be counter-productive because it would detract from the importance of the water, which, by its very nature, always displays more subtle contrasts.

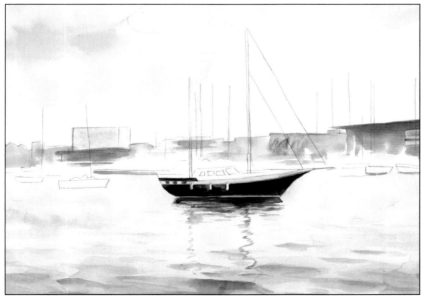

The darkest tone of the whole picture is that of the lower part of the boat in the center of the composition and of its reflection on the surface of the water. These are therefore the visual foci of the scene and those that should be given the most detail. The reflections of the masts have been accomplished simply with broken vertical lines beneath them. The curves described by the reflections are further removed from the vertical the nearer they are to the spectator. The reflection painted on the waves also becomes smaller with distance.

The central boat is depicted in greater detail, while the boats in the background are painted simply as there is always a reduction in detail with distance. The depiction of the waves is more highly developed in the foreground area.

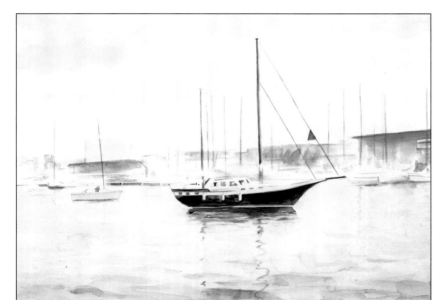

The remaining boats are painted in light shades and their respective shadows are positioned on the water in the same way as with the first boat. The color of the reflections should also become lighter the further away they are. In addition to the reflections of the boat masts, the buildings also reflect their tones on the water below them and, although their outlines do not appear on the surface of the sea because of the distance, their brown shades are depicted lightly in some areas.

perspective: techniques

Step by step

<div align="right">

Landscape

</div>

Natural landscapes provide an inexhaustible source of examples of reflections on water. Lakes and ponds often display on their surfaces the reflected forms of the elements that surround them. In this case, we have taken as a subject a landscape of a lake with trees.

The landscape allows for a huge variety of interpretations, so that, although it is going to be depicted realistically, it is possible to begin with a very loose and spontaneous blurring of the forms. In this case it is useful to search out the dark areas, then highlight afterwards the lightest parts at the top of the wood.

The trees are first painted in rusty green and yellow, both mixed with a little black in order to achieve the different tones shown here. The undergrowth is treated fully and the reflections on the water are first painted sienna. In the area nearest to the vegetation the brushstrokes are elongated and horizontal, while in the furthest reflection they are shorter and more vertical.

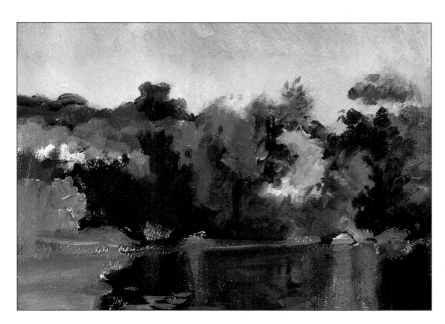

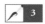

After painting the trees on the right, a dark wash is applied to them that blends in the tones. The work in the picture is centered on depicting the reflections on the water. Observe how the different planes of color are produced, the brightest shine is painted with small, thick, horizontal strokes. The water area is approached via different treatments. Transparency and fusion of tones are used to obtain the reflections while dark transparencies and opaque brushstrokes are used to paint the reflection of the sky in the foreground. In the area to the left of the reflections a huge mass of luminous color is applied.

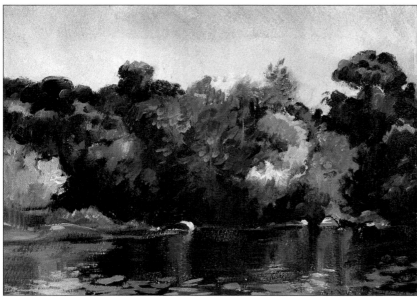

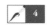

The dark area of the reflection on the right is painted over with a quite transparent dark sienna. The lighter part of this area is painted with light green applied with vertical brushstrokes. The blues that are used for the reflection are painted much more brightly. With this increase in light the whole landscape gains in contrast. We finish off the picture by painting the better illuminated area of water, where the blue sky is reflected, with short, horizontal brushstrokes.

14. Grid or mosaic

When we look at the first pictures that were painted with modern perspective, as we know it today, we cannot avoid being drawn to the magnificent floor mosaics decorated with geometric motifs.

These geometric motifs were so well executed that they almost became the principal focus of the mosaic. This should not surprise us since these geometric motifs formed the basis upon which the first perspectives were created (*fig. 1*).

The motifs are also a useful resource when depicting interiors because they provide a floor on which to position other elements in the mosaic.

As in other parts of this book, we will demonstrate what happens to a simple, basic mosaic, composed of squares placed in sequence, in different types of perspective (parallel and oblique).

Parallel

First, we will examine a mosaic seen from the front, in other words as though we had lifted it from the floor and we were looking at it in front of us. The mosaic consists of a network of squares whose diagonals are parallel in both directions.

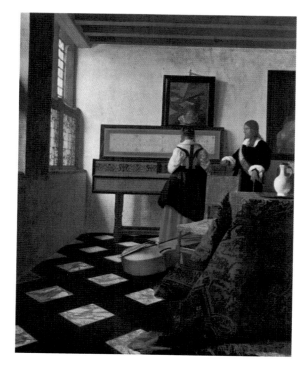

 Fig. 1

The Music Lesson (c. 1660) by Jan Vermeer. Note how the mosaic is used in this picture to decorate the floor, which would normally appear as a plain surface. The artist has taken advantage of this to accentuate the effect of perspective in the composition.

In order to apply parallel perspective, we need to utilize the elements already described in previous chapters: the horizon line (HL) and the vanishing point (VP). In addition, we will also need to locate the vanishing point of the diagonals (VPD).

Figs. 2 to 6

The process of depicting a geometric mosaic in parallel perspective is the same as with any surface, but it especially important to be sure about the divisions. The diagonal crossing the picture should be balanced within the whole.

Once the vanishing point and the first segment, A-B, have been positioned, we will be able to find the vanishing point of the diagonals. This is located above the horizon line, the same distance from the vanishing point as that between the viewpoint and the picture plane.

We take segment A-B and divide it into as many parts as there are boxes in our grid.

From each of these points we draw a straight line that goes to the vanishing point (*fig. 2*).

Then we draw another straight line that goes from point A to the vanishing point of the diagonals. Where this line cuts the straight lines from each of the points to the vanishing point, we obtain the points through which pass the horizontal lines that have just formed our grid (*figs. 3 and 4*).

If we wish to lengthen the mosaic because the room is longer, we proceed as follows: from the last point on the straight line from A to the vanishing point, we draw another line to the vanishing point of the diagonals and repeat what we did with the first grid (*figs. 5 and 6*).

Oblique

In order to depict a mosaic in oblique perspective we must begin by putting in place its distinguishing features, that is the horizon line (HL) and the two vanishing points (VP1 and VP2).

perspective: techniques

119

First of all, we place the axis line (AL) parallel to the horizon line.

On the axis line we place point A, the point nearest to the observer, and the axis point (AP), which will be on the horizon line on the vertical that passes through point A (*fig. 7*).

From point A we run two straight lines to VP1 and VP2 on the horizon line (*fig. 8*).

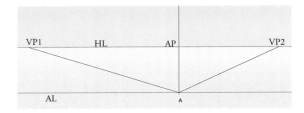

Then we continue by positioning the axis points of each of the mosaic squares, on both sides of point A (*fig. 9*).

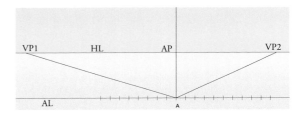

Then, we extend each of these points to the axis point, in blue, and where they cross the straight lines radiating from A, they are in perspective (*fig. 10*).

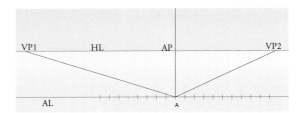

Finally, we join each of these points to VP1 or VP2, respectively. In this way we complete our mosaic (*fig. 11*).

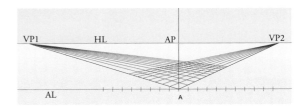

Decorative mosaics in perspective

We have just tackled the problem of drawing a mosaic in perspective. The example was a simple mosaic of square tiles. But we can be sure that we will at some stage be confronted by a mosaic made of different types of geometric shapes. At first this could appear difficult to represent because of the required detail (*fig. 12*). However, the principle of depicting the shapes remains the

Figs. 7 to 11

Oblique perspective requires two vanishing points. The points of the grid move away in both directions towards these points.

same. It is simply a matter of reducing the elaborate versions to the basic mosaic that we just learned how to depict.

In *fig. 13* we can see a series of mosaics that might be found on the floors of older houses and buildings.

To draw this image begin by constructing a parallel perspective. As in other exercises, we put in place the horizon line and the axis line, and then look for the vanishing point of the diagonals. Then we position the axes of the mosaic components on the axis line and extend them to the VP.

From one of the lateral points we extend the vanishing point of the diagonals and in this way determine the distribution of the small squares.

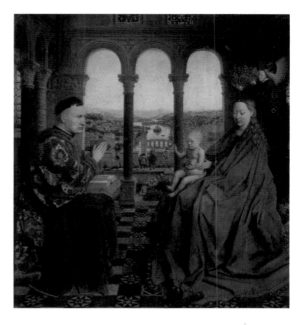

 Fig. 12

This is the painting by Jan van Eyck entitled Madonna with Chancellor Rolin *(1435). On the floor is a real feat of precision in the representation of a decorative mosaic. Its beauty is the result of enormous skill.*

 Fig. 13

Decorative mosaics like those in this illustration are classic ways for artists to depict floors. The complexity of the geometric forms depends on the artist's skill.

15. The human figure in perspective

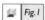 Fig. 1

In this example the foreshortening is not extreme, but is nevertheless a factor to be taken into account in the arrangement of the figure.

Given the great complexity of the human body, it is not possible here to provide a complete guide to its depiction, but we can discuss some of the points with regard to perspective.

As mentioned in previous chapters, both when looking at an object or figure and when beginning a moderately realistic drawing of it, the foreshortening mechanism is applied either consciously or unconsciously.

Foreshortening occurs when some part of the object or figure being depicted is placed in depth, so it appears shortened. If we look carefully, we realize that in reality practically all of the figure appears foreshortened. If we look at a face directly in front of us we see that the ears appear foreshortened, and if we position ourselves so as to see an ear directly in front of us the eyes and the mouth will appear foreshortened.

All the volumetric elements have some of their sides arranged so that they present a foreshortening, but the eye automatically interprets and understands the function of the shortening. In this way, when we see a figure, it does not seem to have one arm shorter than the other, but it is obvious that ithe arm is leaning either forwards or backwards.

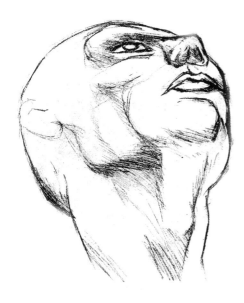

 Fig.2

The effects of foreshortening occur in the whole figure as well as in each one of its parts independently. A head can demonstrate the effect of foreshortening and of perspective. In this drawing the head appears inclined backwards, so that the neck and chin areas appear very large, while the forehead and cranium almost disappear. Likewise all the parts of the face, such as the nose and mouth, are seen from below.

When drawing the human figure it is very important to control these effects, to know how each part of the body should be seen when it is placed in a certain position. Through practicing drawing from life, a certain spatial vision is gradually developed that allows us to mentally visualize the figure and so be able to master the foreshortening and the proportions.

In addition to the subject of foreshortening, it is interesting to bear one other very important point in mind. The human figure, as a visible entity, is subject to the same laws of perspective as any other object.

When creating a composition that includes a human figure, we must apply the same rules of perspective to this figure as to the background or space in which it is placed. If this is not done, the figure will not seem to be part of its surroundings, but to have been cut out and stuck on. Therefore it is very important for the different elements in a picture to be integrated, making the picture seem coherent and natural.

When placing a figure in perspective, the first step is to determine the point from which we observe it. Looking at a figure from eye level is not the same as from the ground or down from a higher point. Nor is viewing a figure from a meter away the equivalent to 15 meters. In a building the lines that are in reality horizontal and parallel move visually towards a point in the distance. In the same way, in the human body the horizontals that mark, for example, the line across the shoulders, also move away depending on the positions of the figure and the observer. The best way of achieving this is to visualize the figure as a simple geometric form and then place it in perspective as we have learned already.

Step by step

When we try to place a human figure within a specific space we must remember that it will have to follow the same laws of perspective as the space in which it is located.

This will be most obvious in instances where the figure is leaning or interacting with one of the architectural elements of the scene in perspective.

In this step by step exercise we provide an example of this. The woman is shown leaning on a table that is placed obliquely, so it is very important to be careful that the figure and the table appear to form part of the same space. Also note that, owing to the proximity of the observer and the model, the leg of the model that rests in front is proportionally larger than the upper part of the body.

 1

First of all, as with the other examples, do a pencil drawing. When the observer is very close to the figure, the effects of perspective, such as foreshortening, appear magnified. If necessary, we should rub out and redraw until the drawing of the model really appears located within the background. It is important to remember that both the woman and the table on which she is leaning are arranged obliquely and that the woman is leaning backwards.

 2

The whole scene will be worked using harmonious colors, that is, those with a similar range. The ground will be a reddish brown, and the clothes a colder pink color (see the chapter on depth through color). In order to be able to differentiate the color tones clearly, the color of the model's skin will be left lighter and with a less rosy hue.

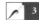 **3**

The first color is applied to the wall at the back, a dark brown, albeit very diluted. If this were applied in a much more saturated form it would come forwards and the effect of depth would be lost. Consequently neither the color nor the drawing on the wall should be too prominent, since they are in the background.

Step by step

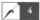 4

We develop further the light and dark contrasts and the modeling of the folds of the dress. The face is still undefined, with only heavy shading marking the eyes, mouth, and cheeks. We can add more details to this base later on, and also apply color to the remaining elements of the composition, such as the chair on which the woman is sitting, and the legs of the table.

 5

Continue to add a little more detail to the initial shading applied in the previous steps. As the model is wearing a dress of a single color this allows us to define in some detail the volume, light, and shade of the folds. This also determines the way we interpret anatomically the foreshortening of the woman's left leg.

 6

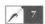 7

The painter decided to give the work greater color intensity, so the reddish color of the floor and the brown of the background, as well as the yellow of the back of the chair, have been made stronger. Note how the shadows project onto the floor so that both the model and the table are located in the space. Without these shadows the picture would lose its unity and spatial reality.

In this last step we can finish defining the form and features of the model. To produce a gloss that helps us with the modeling it is possible to use a little white gouache mixed with the watercolor. In this composition the most detailed point (the foot) is not the nearest, but the scene focuses more on the face of the woman. The foreshortening of the face, as well as the vanishing lines of the floor, emphasize the feeling of perspective.

perspective: techniques

16. Composition with several human figures

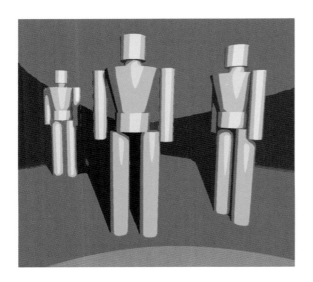

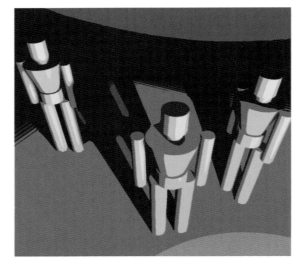

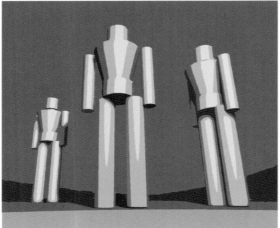

When arranging a group of human figures we must bear in mind both their position and the relative distance between them, and the viewpoint from which we are looking. The distribution of the figures will vary depending on the height from which they are being viewed. It is also necessary for them all to be treated with the same perspective-related criteria so it appears that they are all occupying the same space.

When placing a number of human figures in perspective within a composition, various factors must be taken into consideration in order to present a coherent group.

The first of these factors is the size of the figures in relation to the point in space in which they are situated.

Frequently the space is suggested precisely by the decline in size of the figures that are placed within it. When we see one figure that is smaller than another in a composition, the eye intuitively interprets it as being located further away from the spectator. Readers should by now have developed a certain capacity for visualizing a space in depth, which will greatly assist them when placing the figures in the composition.

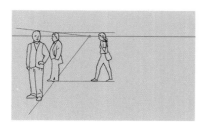

These vanishing lines show how much the figures should diminish in size according to their distance. If we place a new figure at the same height as the previous one on a particular point on the lower line, they should extend in height as far as the upper line.

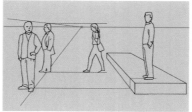

In order to place a figure at a higher level we calculate their height as though they were standing on the ground. In this way we can maintain the same scale of proportion as in the rest of the drawing.

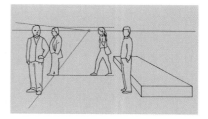

This shows how to take the measurement as if on the ground and apply it to the figure raised onto a higher level. In this example the height at which the figure is placed does not correspond to the depth.

We will nevertheless explain a fairly simple method for placing figures in depth with some degree of certainty.

First the horizon line is put in place and on it the vanishing point. The first figure is positioned at a point in space and given a suitable height. Lines are then drawn running from the lower and upper part of the figure to the vanishing point.

The angle formed by these converging lines will serve as a reference to mark the proportion by which the other figures need to decrease as they move away from the main figure. The lower line will mark the feet of all the figures in depth and the upper line will mark the maximum height. If we place a new figure with their feet on any point on the lower line, we know that their height must extend until it meets the upper line. In this way we depart from the premise that we are working with people of actual equal height. We also know that in reality human beings

present a great variety of heights depending on their age and type. However, this does not pose any obstacle, since it will only be necessary to alter the heights proportionally.

Nor is it necessary to restrict the placement of the figures to the space between the vanishing lines, as they just serve as a reference to work out the heights, with the possibility of moving the figures horizontally as much as is desired.

This method applies only to figures that are standing on even ground. If we intend to position them on any raised surface above ground level (like a pedestal), we must calculate the height from the ground and then add this measurement onto the raised level, which of course must also be shown in perspective.

Figures in perspective

Creating a composition in which a number of figures appear in perspective involves the need to master both correct drawing of the human figure and the rules of space in depth. In the context of this book, the reader should at least be prepared to tackle the second challenge successfully. You must make sure that the size of the figures diminishes according to their distance in a regulated manner and in the same proportion in which the background elements are reduced. Therefore, it will first be necessary to trace the perspective of the space in which the figures will be placed, using the method we have learned, and then to adhere to this same perspective when positioning the people who appear in the space.

For this exercise we will use watercolors because they are at the same time expressive and precise.

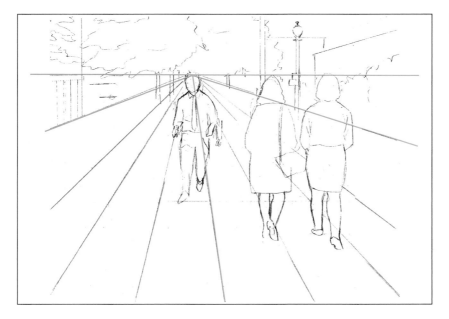

The figures nearest to the spectator are put in place. The two women on the right feature in the foreground and their height will serve as a guide for the other figures that we draw. The man in the center of the picture has his head at approximately the same height as the women (viewpoint height), but it is located at a point that is rather higher within the composition.

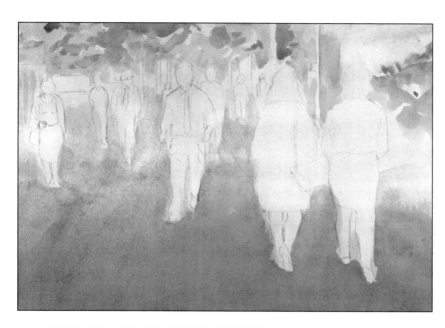

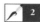 **2**

Begin adding color. First apply a general background tone. On top of this paint the reddish shade of the floor and the green of the trees. These first shades must be light, since they will simply serve as a reference in order to continue coloring the figures. The leaves of the trees must be painted with very loose strokes using very wet paint. We must try, above all, not to darken the areas that will have to be light in the final picture.

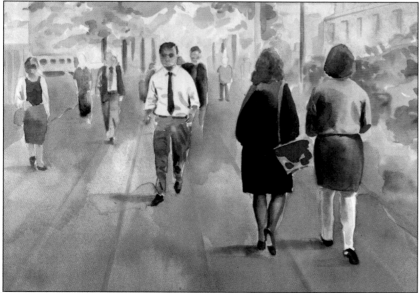

 3

Following the rules given previously, the tones in the foreground are intensified, making the elements in the background appear fainter. As can be seen, the colors nearest to the spectator, such as the reds of the ground, the hair and the bag of the girl, the blue of the skirt, or the yellow of the blouse, are much more saturated, so that a greater chromatic contrast is achieved. At the same time, there is a sharp contrast of light and shade: very dark elements, such as the girl's coat, stand out from the background in quite a pronounced way.

17. Pictorial perspective

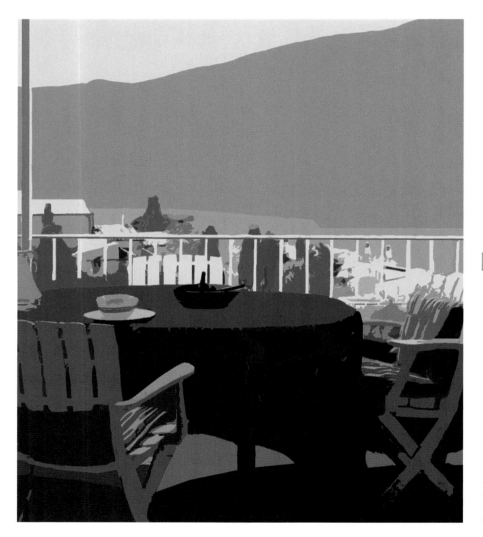

Variation in dark and light exists both in black and white drawings, by the use of grays, and in works in color. In this illustration three different zones can be seen: the terrace in the foreground, a series of houses further away, and a mountain in the background. The foreground has been left in highly accentuated shadow, the second zone has very intense and direct illumination, and the background is in a more diffuse and less contrasting light.

As we have seen, drawing in perspective is an important tool in the expression of the three dimensions on a flat surface, but artistic work requires more than just accurate use of perspective to be considered good. The artist also needs to bear in mind concepts such as light and dark contrast, modeling, and chromatic value. Correctly used, these elements allow us to express depth with greater realism and more expressive force.

Depth through the use of light

Light is one of the elements with a decisive influence on the creation of a scene with depth, because it is by means of light that the volume of figures is perceived and also expressed. The light via which we observe an object has a powerful influence on the way we see it.

Direct light, in general, tends to emphasize details more because the shadows that it casts are seen more clearly and make aspects of the surface of an object more noticeable. If the light is too direct, however, and the chiaroscuro (light and dark contrasts) effect too exaggerated, shadows may hide a large part of the object.

This type of illumination confers greater expressiveness and drama to the picture, but it loses descriptiveness and clarity. In contrast, a diffuse light, such as that of a rainy day, allows things to be seen very clearly, but, when the shadows become too light, objects can lose their volume and appear monotonous.

The use of one type of light or another must be dictated by the type of picture we wish to produce and the feeling that we wish to express through the scene.

More direct light can make an image stand out, so quite an effective technique is to have greater light contrast in the foreground of the composition and to leave the back with a more

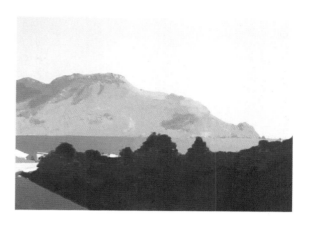

 Fig.2

Here we have another example of how lighting can help to differentiate clearly the zones of a composition. In this case the intensity of the shadow in the foreground has been increased in order to separate it visually from the background.

diffuse light, blurring the outlines and lightening the shadows.

Another technique that helps to differentiate the zones of the picture very clearly is to give them a different intensity of light by alternating light and shade. For example, in a landscape we can leave the center of the composition in shadow (the central zone in terms of the depth), while using an intense light in the foreground and a more diffuse one in the background. Of course, there is no set rule for this type of approach, since it depends on the individual case, but there are a number of ideas that increase our options and can be considered in these situations.

Step by step

Seashore

A marine subject can be approached from very different viewpoints. For example, we can concentrate on a landscape in which only the sky and the ocean appear as the main focus, or on a theme in which either rocks or reefs dominate the composition.

For this step by step exercise we are going to depict a seashore with rocks and cliffs along the coast. The different areas of depth are shown through the varying light contrast in the different zones.

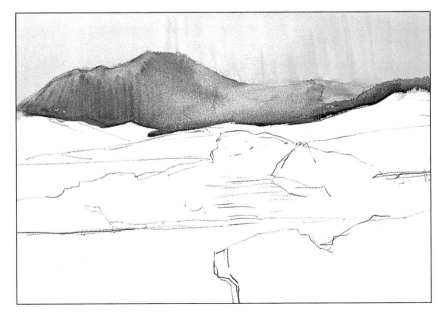

Begin applying color. The zone corresponding to the background (sky and mountain) is painted with a yellowish tone, and the mountains with a bluish color on top of this.

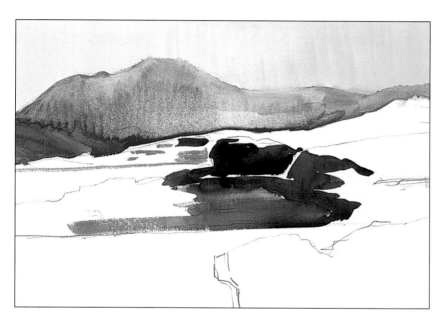

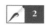

Immediately after painting the mountain in the background, the land in the next zone is painted, which, since it is nearer, appears in greater contrast than the previous one. As can be seen here, the first yellowish wash makes the mountains that have been painted over with a transparent bluish tone seem enveloped in misty atmosphere. On the other hand, the lower, nearer mountains appear much darker and sharper. The area painted towards the foreground corresponds to the shadow between the rocks.

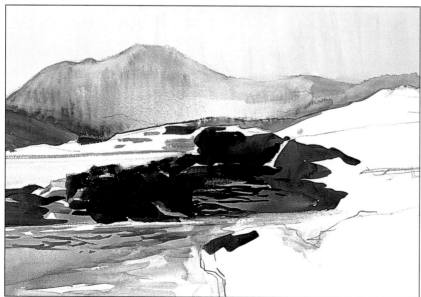

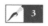

Once the shadow between the rocks has dried, the rocks themselves are painted. This should not present a huge problem as, when dealing with fairly dark rocks, their form can be unifying. The dark reflections of this zone are painted with this same tone using brushstrokes that cut through the color underneath.

Step by step

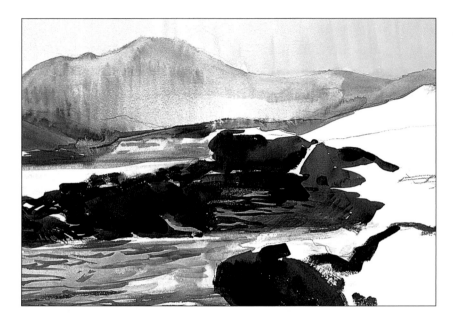

The color of the rocks in the foreground should be sufficiently contrasting that they are visually separated from the other tones in the background. We need to study the landscape carefully: the nearer the rocky area appears to be, the greater contrast it has and the less bright it is. The color used to create these rocks is a mixture of Van Dyck brown and dark blue.

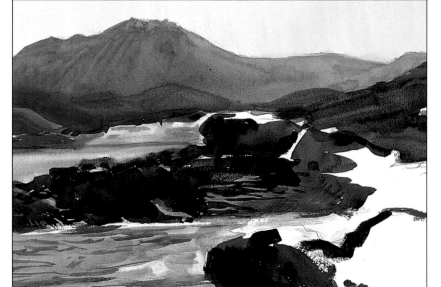

The mountains on the right are painted in a rather dirty greenish shade, mixed with a violet color. In this zone we leave unpainted the light area which corresponds to the small white house.

The difference between the foreground zone with the water and the zone behind is clear; this second zone is painted with a blue color wash. The horizon line is marked with successive sweeps of the brush, until it is well defined.

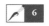

In the background zone with the village, a contrasting color of darker violet is applied. With the sea in the foreground, successive brushstrokes of highly transparent cobalt blue are applied. Some areas, from where the sea begins, display great luminosity. We finish painting the rocky mass in the foreground, although not in the final color.

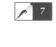

In the water in the foreground new contrasts are painted with cobalt blue; this time the reflections appear much brighter, which has the result of emphasizing the effect of perspective. A patch of very dark brown shadow on the rocks in the foreground completes this view of the seashore.

perspective: techniques

18. Depth through color

 Fig. 1

In the distance colors become colder as they tend towards blue, and then gradually become lighter and grayer. Where this effect tends to be most evident is in mountainous landscapes, in which the furthest mountains start to become confused with the white of the sky.

There are three basic colors: yellow, magenta, and cyan blue. All the rest are achieved through the combination of these three colors. If we mix these colors in two equal parts, we obtain the secondary colors. Green comes from mixing yellow and blue, orange from mixing yellow and magenta, violet from mixing blue and magenta. Complementary colors are those that do not share any color in their mixture and therefore contrast most strongly with each other. For example, yellow and violet are complementary colors since violet contains blue and magenta, but not yellow. Following the same procedure of mixing two primary colors and setting them against the third, we find that blue and orange (a mixture of magenta and yellow) are complementary, as are magenta and green (a mixture of blue and yellow).

Applying this to our knowledge of the effects of depth we may conclude that the use of highly contrasting colors (such as the complementary ones) should be used in the foreground, while the more harmonious color combinations are used in the more distant areas.

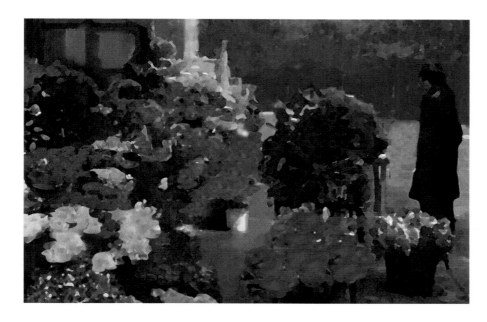

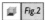 Fig.2

The very strong colors in the foreground help to strengthen the effect of depth. The pairs of complementary colors, such as yellow and violet, create a strong contrast and bring forward visually the zone in which they are situated. If the same color saturation had been used on the trees in the background the scene would have suffered a substantial loss of perspective.

There are also colors that, because of their visual effect, are considered warm, such as red and yellow, and others that are regarded as cold, such as blue and violet. The warm colors give a feeling of proximity, the cold ones distance. Foregrounds offer more lively, warm and contrasting colors and backgrounds bring colder, grayer and less contrasting colors.

If we look at a landscape with mountains in the distance, we notice that, the further away they are, the lighter and bluer their color, contrasting less and less with the color of the sky. This is one of the clearest examples of the ideas that we have explained in this chapter.

 Fig.3

If we juxtapose harmonious colors such as those shown here, the result is that the elements on which we use these colors lose chromatic contrast and visually distance that area of the picture.

perspective: techniques

Step by step

It is not always necessary to use the resources of linear perspective explicitly when trying to show depth in space.

Often, when we are painting a natural landscape with irregular features, there are few elements suitable for linear perspective that would suggest distance strongly enough.

It is in these cases that the options offered by what we have called pictorial perspective are most needed. In this exercise, carried out in pastel, we will see how, in addition to saturation and color contrast, the drawn line also has a function in the representation of depth.

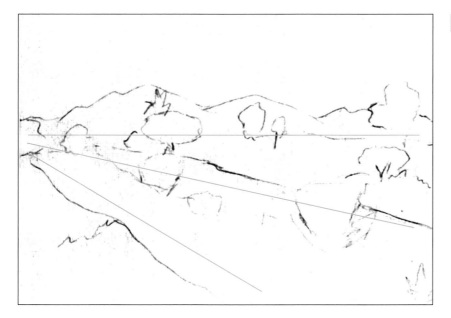

The initial sketch does not need to be drawn with great precision, since all the elements included have irregular forms that offer a huge margin of variation without losing their realism. The principal forms are arranged leaving the small details to be dealt with at the color stage. The road that traverses the scene towards the back will be what helps us to express the depth in this picture.

The first application of color must be light. Pastel is used without excessive pressure in order to avoid leaving heavy marks and it will then be blurred with a finger or cotton ball. This creates a base on which to add the details later. In this first application only warm colors have been used, such as yellow, red, and an earth color. It is important to remember that it will always be easier to "cool" a warm color afterwards than to carry out the operation in reverse.

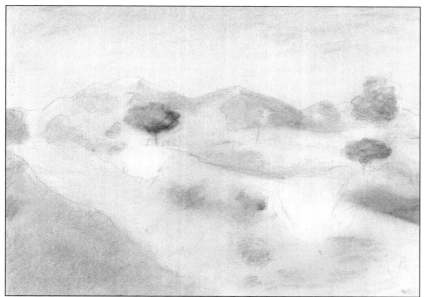

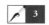

Continue applying the color of the sky as we explained previously. It is not advisable to emphasize very much the contrast between the sky and the mountains in the background since, as we have noted, strong contrasts tend to bring forward the area in which they are applied. More details, such as bushes and hills, are gradually put in place in the countryside, while always bearing in mind the overall picture.

Step by step

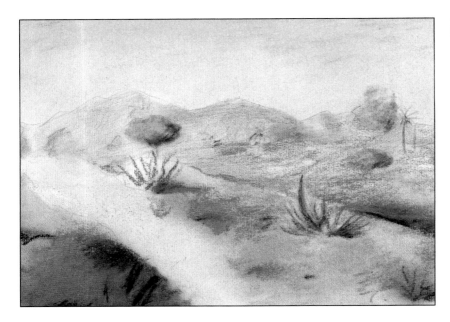

When drawing the different plants and cacti that are spread out on the ground, we have to tackle them in different ways depending on where they are positioned. The furthest away are barely marked but they will be given greater definition the nearer they come to the foreground. As we can see, a very intense mixture of green and yellow has been applied to the bush on the left and some very marked black lines made on top of that.

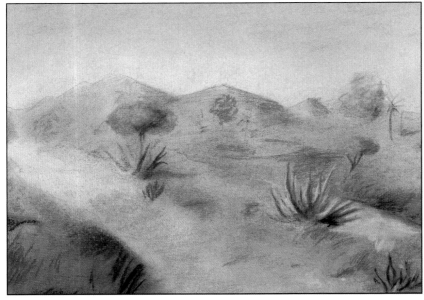

In order to create the foreground, the warm colors in the lower part of the picture are intensified. The yellow of the ground becomes more saturated in this area and some reddish lines are also added to the bush on the left. The white lines that cut across the cactus on the right create a strong contrast with the shadows cast by its leaves.

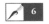

Now the mountains in the background can be defined more clearly, since we already have the foreground as a reference, though they will always have lower intensity and be less of a contrast.

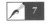

One of the advantages of pastel is that it makes possible a wide variety of treatments, which have been used here to express perspective. As we said, lines are one more factor that can be used to suggest depth. While the sky and the mountains in the background have been gently blurred with a cotton ball, all the elements in the foreground have been worked with highly defined lines. Stones, leaves, and spines have been drawn in this way.

perspective: techniques

143

Step by st

ep exercises

Step by step

1. Nature with reflections

Given the variety of forms and displays of color that the countryside can offer, this is one of the most interesting subjects with which to put into practice all the skills that we have acquired throughout this book.

In this new landscape example, we can observe the differences between the different areas that exist in almost all compositions.

The direction of the brushstrokes will help us to show the difference between the trees in the background and their reflection in the water.

Drawing is one of the principal technical requirements of the artist. Sometimes it will have to be very detailed and precise; at other times, such as here, it will provide a preparatory sketch for a composition. We apply an irregular sienna color wash on the outline of the principal landscape forms around the river and clouds.

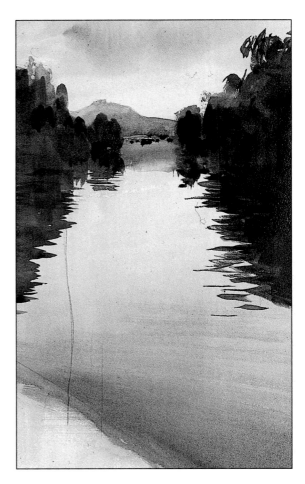

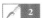 **2**

To create the reflections we extend the intense blue color of the trees on the left onto the river surface, but, to produce the effect of the shapes reflected in the water we draw them horizontally and foreshortened.

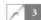 **3**

We finish the right edge with a mixture of green and blue, which we make use of to paint the reflections on the water. Note that we have applied a very thin grayish blue wash in the lower area. This helps to bring this part of the water nearer to the spectator.

Step by step

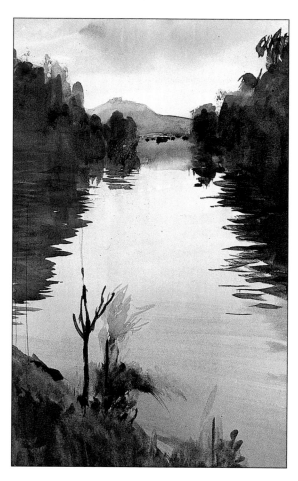

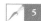

We paint the foreground in blue, green, and ocher tones in a more saturated form. This way we manage to establish the different areas in a more definite way.

The principal color masses of the landscape are now in place and we can begin to paint the trees on the bank. The shapes of the tree branches should remain quite firmly outlined against the surface of the water in order to separate these two planes.

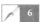 6

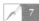 7

We now focus our attention on the sketching of the bare trees. In the example, they are very graphic; first we paint the trunks and then, with much finer brushstrokes, the rest of the branches.

In the final picture, the mountains in the background of the landscape have been painted with a lightly saturated blue wash that blends with the sky at the top. The three brown shades, applied just under the trees, are the warmest in the whole composition and, situated in the foreground, reinforce the effect of perspective.

step by step exercises

Step by step

2. House and path

When we are producing an exercise in depth based on a landscape, one of the most useful techniques is toning the image with a base color that will unify the picture.

In this specific exercise, a drawing of a landscape has been done using charcoal. We have used an eraser to bring out gloss and light in certain areas.

Note that the viewpoint is raised, so the horizon line is low within the composition. As a result we have a wide space in the sky for introducing light into the scene.

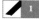

First darken the whole of the paper with charcoal, taking care not to leave fragments on the surface. The paper must be completely covered to provide a base on which to work the lights and shades. The initial lines of the arrangement are drawn on top of the extensive shaded area, which will enable us to place the elements within the space.

With the eraser we begin to extract light tones in the lower part of the sky, that is, the section on the right just above the mountains.

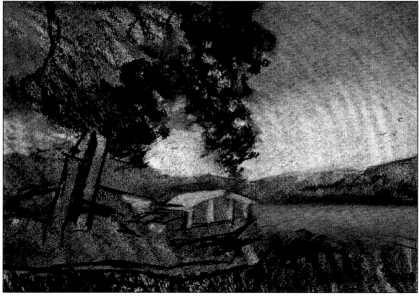

With the eraser we continue producing light areas, in a more subtle way, on the house and on the ground to the right of this. With the charcoal we darken the foliage of the tree and on this area we apply the eraser in such a way that patches of light appear, just like the effect of the sun through the leaves.

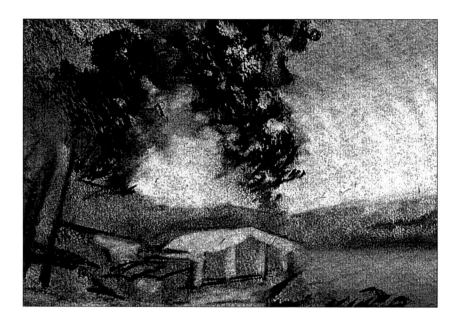

Here, the white gaps made with the eraser achieve the same outline effect as when done with charcoal. In the picture we can appreciate that the open light areas tend to join together, which is why it is necessary to continue applying the charcoal to blend the different tones of gray.

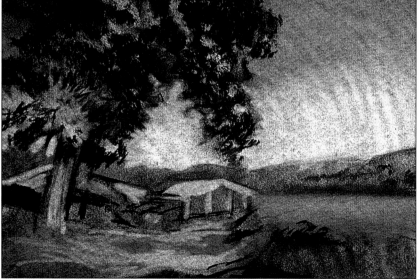

Using the point of the charcoal, we stress the dead leaves with the picture's darkest colors. In the foreground of the landscape very dense dark tones are also used, which, via the eraser, turn into the open area a little higher up. The darker tones at the bottom separate the foreground and background planes, emphasizing the effect of perspective, which gives us the illusion of depth.

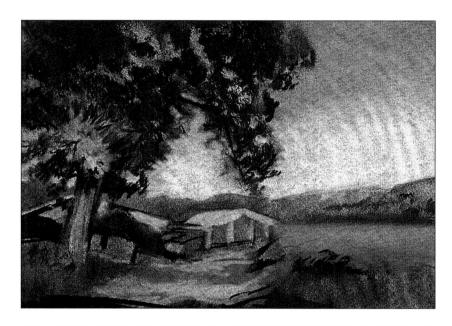

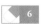

With the eraser the white areas representing the ridged texture of the tree trunk are reopened. Charcoal is applied harder to finish defining the volume of the trunk. The form of the house is drawn in more detail with charcoal.

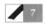

The maximum contrasts are achieved by applying the tip of the charcoal to areas that have had white paper restored with the eraser. That the mountains in the background do not have a defined profile helps to create the effect of atmospheric depth.

step by step exercises

Step by step

3. Boats

In this view of a canal in Venice we can see an interesting combination: the use of perspective with buildings, and reflections in the water, common in marine views. Because the viewpoint of the observer is elevated, this scene is depicted in an aerial perspective.

The placing of the boats alternately on the left and right edges of the canal helps to suggest the depth of the image, while at the same time conferring greater visual dynamism. Similarly, through gradual steps we will see how the use of color can be helpful in creating the foreground by strengthening the effect of perspective. As can be seen in this composition, the horizon line cannot be seen, since it is totally hidden by the houses; however, this does not pose any problem, because the vanishing point is enough to guide us.

 1

As we can see, all the vanishing lines move towards the same point. This does not happen with the elements of the houses in the background because they are oriented differently; their respective vanishing points are situated elsewhere. As usual, the rest of the houses should also be drawn with the guidance of a vanishing point, even though it can only be approximate.

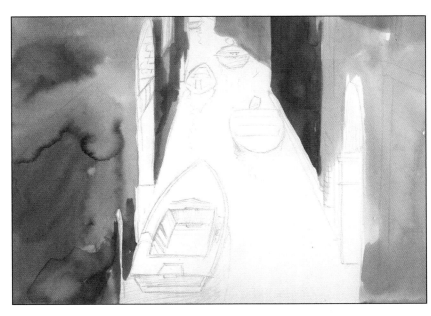

We begin painting by applying a light coat of a reddish brown shade in very diluted gouache. This coat is simply meant to be a guide to assessing the colors that we will add later so that they remain in harmony and the painting has a certain chromatic unity.

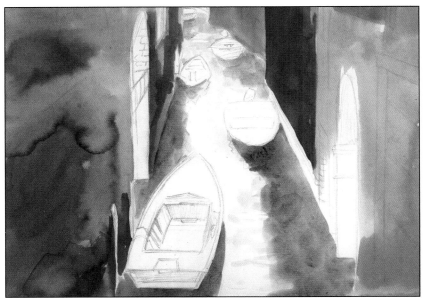

For the water we apply a slightly darkened blue tone. If this blue were too pure (that is, an oversaturated tone) the contrast with the reddish color of the walls would be excessive and the painting would have an effect that was too highly colored and not very realistic. The central zone of the water is left white to show the reflection of light on its surface. The shading towards the center has been made with loose horizontal brushstrokes in order to imitate the movement of the waves on the water.

 # Step by step

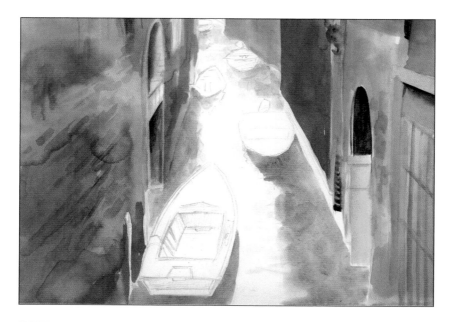

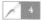 4

We continue applying a first coat to elements such as the doors of the houses, the bars on the right, and the moss on the walls. Before launching into painting large areas in the final color, it might be useful to try different tones (such as moss green) so that we can see how they interact with the other colors in the composition.

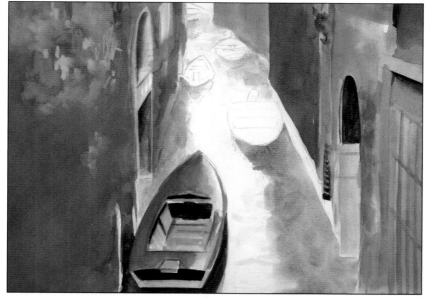

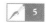 5

The color of the wall in the foreground is very strong as the gouache has been applied more thickly so that the area advances towards the spectator. In contrast, the houses in the distance are the most transparently painted and in the least saturated colors. The boat nearest to us must be in greater detail than the rest.

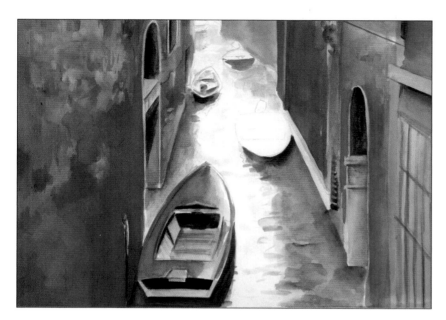

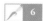

The contrast between the reddish tone of the wall, the blue of the water, and the green applied to the wall on the left give a greater feeling of depth to the scene. The doorways have a dark tone, since we have the sun in front of us (although it cannot be seen), and these areas are in shadow.

This is the final result. The effect of depth is suggested by all the factors we have discussed previously. We can see that the lower parts of the boats create the greatest shadows on the surface of the water. In contrast, for the stretch of water and the houses in the background, the white of the paper has been left untouched and the greatly diluted paint has a spontaneous finish.

step by step exercises

157

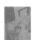
4. River bank

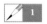
1

The banks of rivers are perfect subjects for studies of reflections as well as the horizon line.

In this case we can see that the reflection is produced by a narrow fringe of vegetation that runs from left to right of the picture and in which two large masses of foliage stand out.

We begin by tracing in charcoal a simple arrangement of general forms. The horizon line is situated at a fairly elevated point of the composition.

The reflections on the water are also roughly drawn so as to facilitate the later work in color.

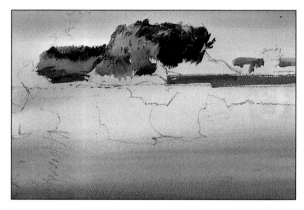

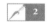
2

We begin to apply color to the paper by means of very diluted watercolor washes, applying successive horizontal coats of superimposed colors that meld together in a very subtle manner.

Note that the area of greatest luminosity belongs to the sky in the background of the picture, so in this part we will leave a margin in which we hardly apply any color.

Next we begin to color the central area of vegetation. We start with a light green tone that we blend with another darker green. The grass nearest to the bank of the river will have a warmer tone to the right, so we are going to apply a not too intense mixture of ocher and orange.

3

With the same blue color used previously for the bank, we now paint its reflection in the water but the tone is darkened slightly with a little more green, without actually changing the color.

We also begin to paint the reflection of the trees in the water. The reflection is made up of small horizontal marks that define the form of the trees loosely, but inverted. First this is painted in bilious green mixed with dark green and blue. Moving down the reflection fewer dark tones are used.

We continue in the reflection zone; this time we begin the most illuminated part with an undarkened bilious green.

Depth is given to the reflections with a dark green wash onto which some strokes are applied directly in the same color but much more densely.

Dark areas are established in the wooded zone. For the darkest part of this area, dark blue is mixed with green. Dark blue notes are painted in the shadow zone, but in this case they are not mixed with another color. We start on the first branches of vegetation on the right.

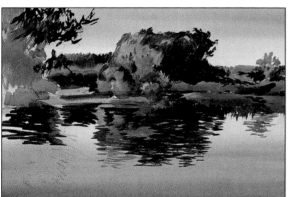

The picture is focused on the right. First, we apply the yellowish tone, mixed with ocher and a little blue to cool it down, in quick, expressive strokes. This yellowish color will be the base for applying later brushstrokes, so it does not require any detail. We continue in the top left corner, where the dark leaves are painted over the light green. The framework of branches and trees on the left of the picture are attended to next.

The main branches are first drawn with the brush and then the small branches, which are converted into the little patches of color representing the leaves. We paint the base of this group of trees dark blue. The reflections of this blue zone are depicted in the same way as the central bright area, but with a visible variation on the chosen green.

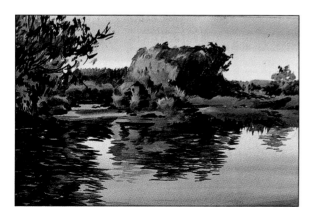

The color nearest to the bank is made much darker than the middle tones. The brushstrokes forming the central bright zone are horizontal and short, and some warmer patches of color are outlined that will serve as a base for the continuing elaboration of the reflections in the water. See how certain of the areas in the background are left blank. Some luminous blue notes are added to the right of the landscape. We complete the vegetation and reflections on the left, the network of leaves in the upper zone standing out against the yellow through its detail and dark tone. With this last part the balance between the different masses of light in the picture is achieved.

Step by step

The rules of perspective must be kept in mind for all subjects. In a small still life, we must be careful that the lines maintain a spatial coherence, especially in the case where there are orthogonal elements such as boxes, books, or furniture. Circular forms should also be correctly placed in space.

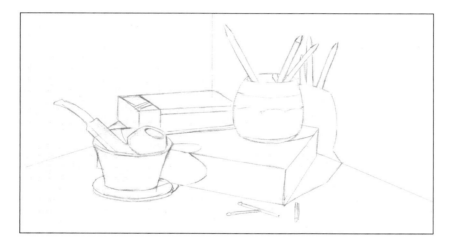

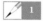

The shadows projected onto the wall and the back of the book are a particularly interesting element for suggesting the volume of the forms, since they clearly describe the angle made by the book. As we can see, the scene has lateral illumination that casts well-defined shadows, due to the fact that the light source is situated near the objects in the composition.

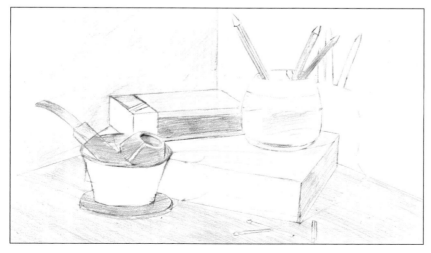

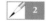

We begin to apply the color gently, trying to follow the direction of the objects with which we are dealing. In other words, if a wall definitely inclines forward, we use this inclination in the brushstrokes that we apply. The range of colors is fairly limited, based on browns, ochers, and some blue, so we will have to work more with shades to differentiate between the objects.

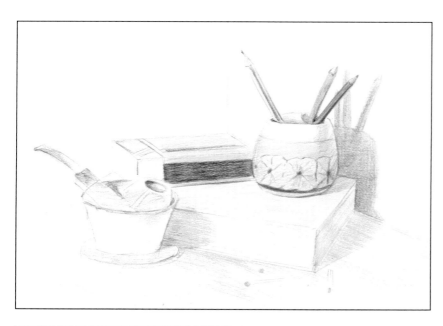

Next, fill in the details of all the elements that are situated in the middle ground. Without too much pressure we can achieve a fair approximation of the small details that provide a greater feeling of realism. It is not wise to have great contrasts on the objects that are furthest away, because this would bring them forward.

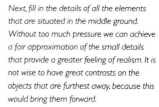

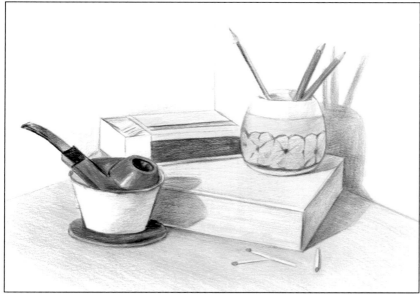

Finish by adding the details of the elements situated in the foreground. Here it is a good idea to achieve the greatest contrast possible, so we intensify the reddish tone of the pipe and also try to saturate the blue behind it as much as possible. These are the two most saturated colors of the whole composition. The ocher of the table is also intensified on the lower part and the strongest shadows fall on the pipe and on the dark brown base. The final result has a three-dimensional feeling in spite of the elements being placed in a very tight space.

step by step exercises

 # Step by step

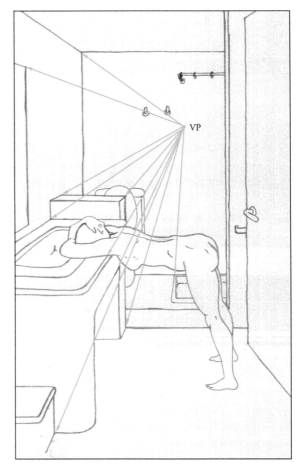

6. Bathroom

Interiors can provide excellent subjects for practicing different aspects of perspective.

In this example we are faced with a bathroom in which the perspective is exaggerated because of the tiles that cover the floor and walls. The door of the bathroom, being half open, follows a different perspective.

At the same time, a nude female has been included, which makes the scene more complex. Note how the body also follows a perspective, demonstrated by the placing of the hips and legs. The leg in the middle ground is reduced in size in relation to that nearer to the spectator.

 1

First, we make a simple pencil drawing in which we position the principal elements, following the lines running towards the vanishing point, as can be seen above. Because the bathroom door is half open, it corresponds to a different vanishing line.

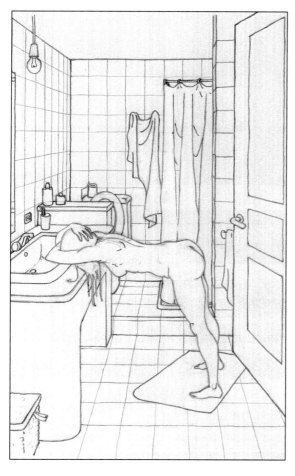

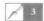 2

Next we position the tiles, which also follow the vanishing lines of the room. Note how the tiles at the back do not follow any type of perspective since they are facing us. The floor rug does not follow this perspective either as it is twisted round. Then we put the remaining elements in place.

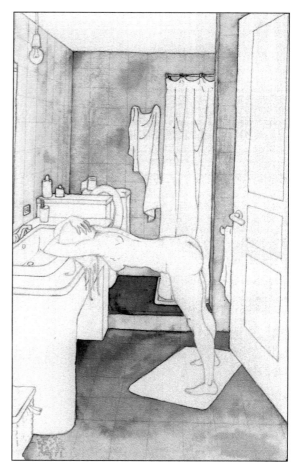

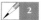 3

We start to apply color on the walls and the floor. For the walls we use a very diluted grayish blue tone, while for the floor we have a very intense dark blue. Using these two tones allows us to strengthen the feeling of depth.

Step by step

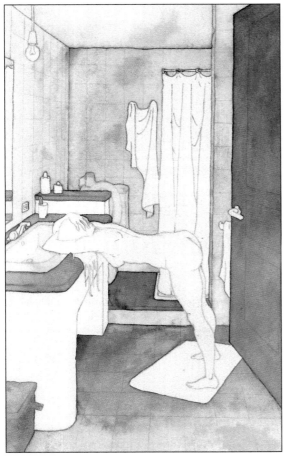

 4

We continue applying color to the composition, keeping within the cold chromatic range. We use an intense green color for the door and the furniture. The basket in the foreground has been painted in a dark ocher, in order to break the chromatic homogeneity and thus to distinguish the different sections.

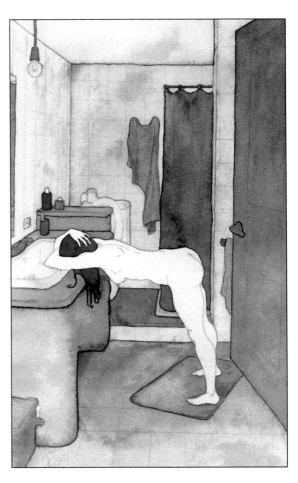

 5

Now we will be able to finish applying color to the remaining elements in the bathroom. Note how a darker patch of color below the washbasin emphasizes the impression of depth. The mirror has been given a color similar to that of the basin but lighter, a result of the optical effects of the reflective surfaces.

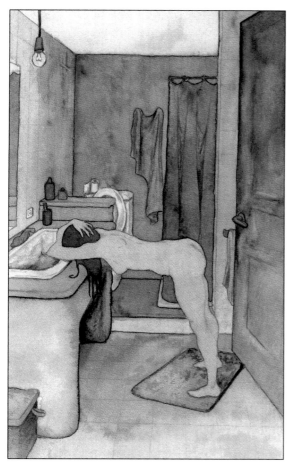

 6

Next we begin to apply color to the model. This task does not try to capture the actual colors realistically, but it makes use of perspective by using colors of the same chromatic range. In this example, the artist has opted for a range of cold colors based on blues, greens, and violets.

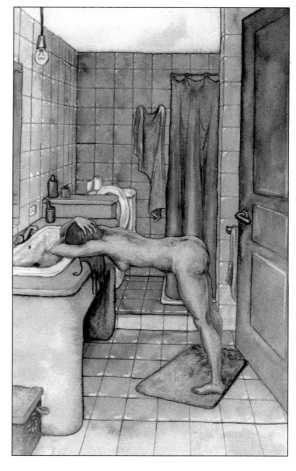

 7

To finish, we proceed to modeling the figure. For this we apply the same skin color, only darker around the edges, which is the best way to express the volume of the figure. Making a more defined drawing of the wall tiles increases the effect of perspective in the composition, since the vanishing lines are evident.

step by step exercises

Step by step

7. Landscape

The interpretation of reality should be one of the most important questions for the painter. Often elaborations are added in painting that do not exist in reality, or conversely real elements are toned down. In this case a landscape at dusk is being painted. Sky is the main feature and for this reason we will place the horizon line low, in order to be able to work on a wide stretch of the area which interests us.

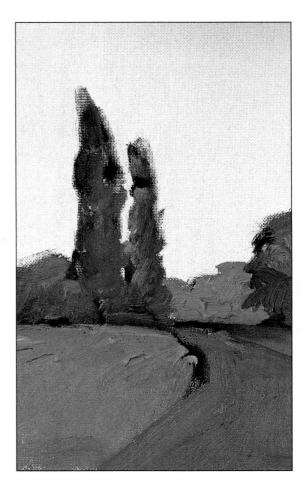

We begin by drawing a simple sketch in charcoal, in which we position the horizon line, the trees in the background, and the large cloud in the sky.

 1

We apply an orange color to the sky, providing a strong contrast to the dark violet tone of the clouds. By using these shades we will ensure that the volumes take shape on their own.

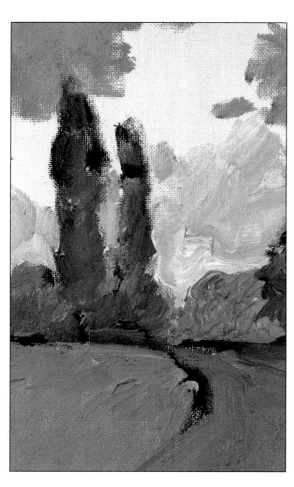

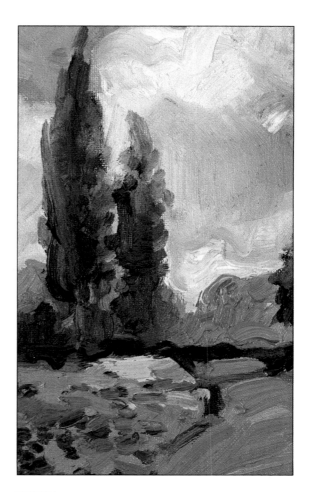

 2

By applying grayish white onto the great mass of cloud, we manage to balance the sharp contrast marked previously. Having just completed the sky in orange, the landscape is painted in two tones of green. Note the type of stroke and the absence of fusion among the colors, which enables us to give a fresh sensation to the composition, as well as marking perfectly each one of the elements.

 3

Finally, the flowers on the ground are painted with small, brisk stabs of red. This warm and saturated tone ensures that the effect of perspective is emphasized. Note how a simple theme such as a sky at dusk can be dramatized by merely lowering the horizon line and emphasizing colors appropriate for this hour of the day.

Step by step

For this exercise, we have chosen one of the most common themes, a natural landscape, as the basis for applying different perspective techniques.

We will see how a simple landscape can be transformed through the application of color into something dynamic and full of composite and creative strength.

For this landscape we will be using watercolor pencils on paper.

First arrange the main forms in the composition. This will help ensure that everything we wish to depict in the picture will remain correctly positioned within our frame.

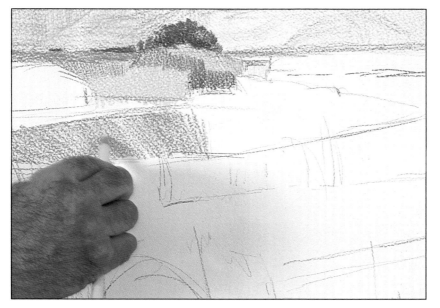

Note that with the zigzag line of the river we have managed to create a dynamic composition. We begin to introduce color in an orderly way. A bluish lilac tone helps us to establish the edge of the mountains in the background and we highlight the bushes in the center with a range of greens. We shape the mounds of earth with orange ocher tones.

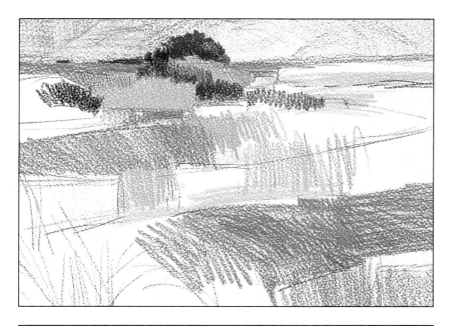

Then, using loose strokes, introduce part of the vegetation that borders the river bank. Apply a compact patch of a not very intense green color for the vegetation situated at the rear right.

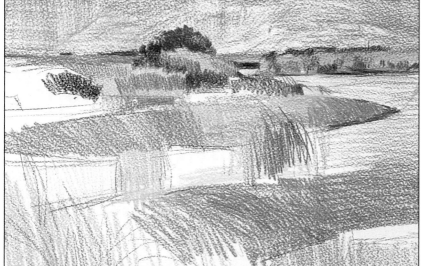

We continue drawing the vegetation in loose strokes, which, as we continue superimposing, will allow us to define the forms.

Step by step

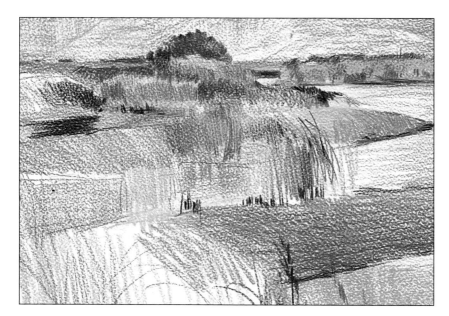

Color the river blue and blend the mounds of earth with a dark brown shade. In this way we are able to establish the areas of the composition more clearly.

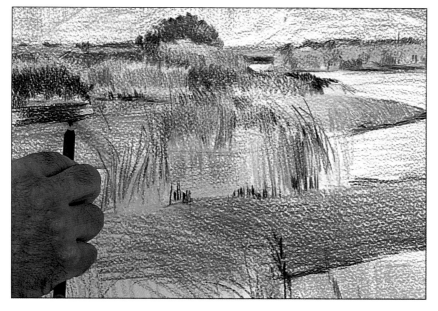

With a dark color we tone the shadows of the bushes and define parts of the foliage in the foreground. The result is a foreground differentiated from the rest of the composition.

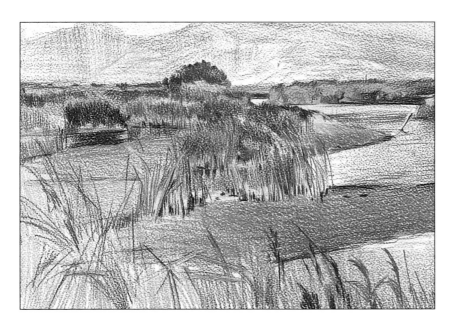

The forms have now been defined and will help us later when we dilute them with the paintbrush. This has to be done because contrasts are the foundation of this picture. In the same way as watercolor, the light colors must be light right from the beginning, otherwise the area would all be shaded.

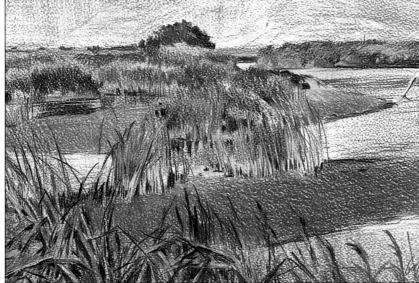

With the help of a wet paintbrush, we gradually dilute the color of the watercolor pencils. Note how the texture has changed. We started off with hard pencil and have ended up with soft watercolor. The colors we applied have blended into the paper, in a way that best defines all the areas of the picture.

Step by step

Paths are usually a good subject for showing the perspective of a clear form, as the irregularity of natural shapes can complicate the perception of the effect of perspective if there is no element arranged spatially.

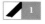

The posts on the left side of the path also gradually diminish as they near the vanishing point.

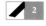

The sketch of the landscape consists of initial lines that enable the different masses of the subject to be positioned. The brown patch of ground in the foreground is depicted more strongly than the mountain in the background in order to highlight the effect of perspective.

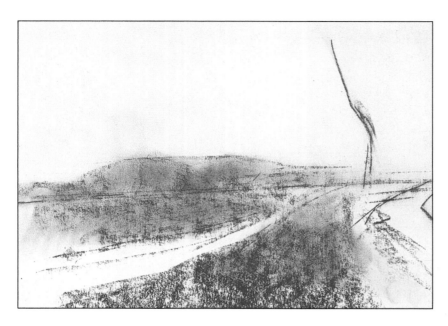

The arrangement of the principal lines is put in place. For this exercise we will use simply three tones: a reddish brown made with a blood red, a charcoal black, and a little white chalk for gloss. On the initial drawing, the lines of the path should converge at a point on the horizon line, that is, at the vanishing point of this parallel perspective.

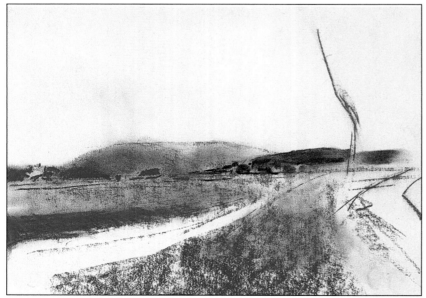

Black is applied to the mountain at the back right. Note how at this stage this zone appears to come forward. This effect will be corrected when painting the forms that appear in the foreground.

Step by step

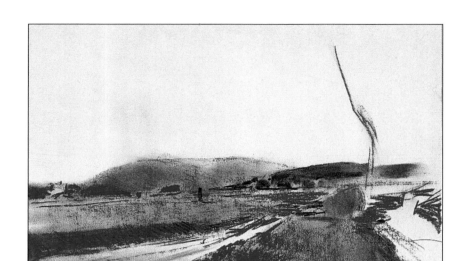

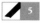

We now begin to paint the shapes in the foreground. When painting the nearest elements, we will apply more detail, depicting with charcoal and blood red the texture of the grass at the foot of the picture.

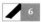

The tree on the right of the composition is positioned. This is done with a darker tone than the rest of the picture so as to highlight this area, as it is the focal point of the entire scene. Also, we start to put in place the posts that traverse the picture in depth from left to right.

We continue to position the rest of the wooden posts. Although they are not hammered into the ground completely vertically (they do not form a perfect line), they gradually diminish with distance in a more or less regular way and, if we analyze the form of the drawing, we will obtain some vanishing lines.

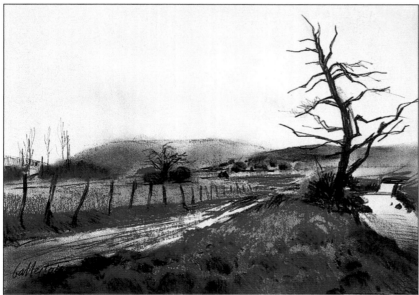

Finally, we reinforce the effect of perspective through contrasting light. The strongest contrast in the whole composition is between the black of the tree and the area remaining white at its foot. The lines drawn on the path reinforce the effect of perspective when following its course. The lower part of the picture, the foreground, is dealt with in more detail and is less blurred than the background.

step by step exercises